20

Uncommon Spirit

Sculpture in America 1800-1940

by Susan E. Menconi

April 22 through June 9, 1989

Hirschl & Adler Galleries, Inc.

21 East 70th Street, New York, N.Y. 10021

Front Cover:
ELIE NADELMAN (1882-1946)
44. *Dancer,* about 1918-19

Back Cover:
WILLIAM RUSH (1756-1833)
1. *Eagle,* 1811

© Hirschl & Adler Galleries, Inc.
Library of Congress Catalog Number: 89-083866
ISBN: 0-915057-29-8

INTRODUCTION

Uncommon Spirit: Sculpture in America 1800-1940 is the third in a series of exhibitions at Hirschl & Adler focusing on the development of the art of sculpture in the United States. It follows *Carved and Modeled* of 1982 and *From the Studio* of 1986, and, for the first time, includes a selection of American folk sculpture, chosen from the collections of Hirschl & Adler Folk. The title and underlying theme of this exhibition— "uncommon spirit"—are perhaps best characterized by the two works illustrated on the front and back covers of the catalogue, and by their respective sculptors, Elie Nadelman (1882-1946) and William Rush (1756-1833).

William Rush of Philadelphia, acknowledged to be the first "true" native-born American sculptor, faced seemingly insurmountable odds in his chosen career. At the end of the eighteenth century there were no master sculptors in this country from whom he could learn his art, nor any schools or academies at which he could study; yet Rush pursued, with great talent, not only the necessary task of learning the art of sculpture, but also, perhaps unwittingly, provided models in the form of his own work for others to follow, thus laying the foundation for the art of sculpture to develop in the United States. The "uncommon spirit" and determination of this sculptor is manifest in his *Eagle*, whose commanding size, heroic character, beautiful proportions, and intricate carving belie the largely untrained beginnings of its maker.

At the other end of the spectrum is Elie Nadelman, who had the advantage of formal training and exposure in Paris to the complex artistic traditions of the Western World before emigrating to America. At first he began sculpting works that were inspired by what had gone before him, and his female nudes and "classical" marble heads found great favor in the artistic circles of Paris, London, and New York. Not satisfied, however, to continue along those lines, beautiful as these objects themselves were, Nadelman took off in a new direction which proved both very controversial and extremely unpopular. His new work, of which the *Dancer* on the front cover is a particularly spirited example, was disliked and ridiculed immediately by the critics and his public, who felt that the artist was mocking them in his depictions of figures with a distinctly contemporary look. In a few short months Nadelman went from being the toast of New York to being the scourge of New York, and his reputation never recovered. He abandoned populist taste for a greater, more original vision, which proved to ruin him professionally and, ultimately, financially. Ironically, it is the very works that brought about the decline of his reputation that are now regarded as his masterpieces, and have contributed to his international reputation as one of the most important early twentieth century sculptors.

Between Rush and Nadelman a host of American sculptors pursued their art despite adversities. The neoclassical artists, recognizing that it was impossible to be a sculptor in marble in America in the early

nineteenth century, packed up their families and moved to Italy, where many of them remained for the rest of their lives. By around 1850 or 1860 a significant community of American artists had developed there, but the first sculptors to go to Italy—Horatio Greenough, Thomas Crawford, and Hiram Powers—were the real leaders, and, because of their pioneering spirit, an American expatriot school of sculpture was established.

The untrained folk sculptors who remained at home created work that generally had a functional purpose. Weathervanes, cigar store Indians, and whirligigs were among the objects they made, and the best of these exhibit a wonderful sense of style and character. The spirit inherent in these works often served as inspiration to later generations of American sculptors, particularly Nadelman and Robert Laurent, both of whom assembled collections of American folk art.

The sculptors in bronze and marble of the later nineteenth and early twentieth centuries, the period that has come to be known as the American Renaissance, studied their art in Paris and brought home with them a sense of optimism and a new monumentality, which is reflected in the heroic sculptures they created for public squares and public buildings across America. And the generation of twentieth century sculptors who were born abroad—Nadelman, Alexander Archipenko, Gaston Lachaise, Laurent, et al. —brought with them first-hand knowledge of the exciting artistic experiments of the early years of this century and infused their American works with a spirit of innovation and modernity that acted as an antidote to the conventions of the popular Beaux-Arts style.

The making of sculpture, by its very nature, poses a unique set of logistical, mechanical, and financial challenges for an artist. Transporting a block of stone from Italy, or modeling a work in clay, then having it cast in plaster and shipped off to a foundry (often in Europe, at least in the case of the earliest American bronzes), is a complicated, daunting, and highly expensive proceedure. When coupled with the fact that the audience for sculpture is generally more limited than for its sister art of painting, it is not surprising that there were—and continue to be—far fewer sculptors than painters. Artists who choose to be sculptors in the first place exhibit a large measure of "uncommon spirit," and that spirit is mirrored in the oftentimes extraordinary sculptures produced by these artists, many of which are included in this exhibition.

* * * * *

I would like to thank a number of our professional colleagues whose participation in this exhibition is greatly apppreciated. Janis Conner and Joel Rosenkranz of Conner-Rosenkranz, New York, were particularly helpful, both with information and objects. Alexander Acevedo of Alexander Gallery, and David Henry and Ira Spanierman of the Ira Spanierman Gallery were most cooperative, as were Carole Pesner of Kraushaar Galleries, Virginia Zabriskie of Zabriskie Gallery, Howard Godel of Godel & Co., and James Maroney of James Maroney, Inc., all of New York. To each of them, I extend my warmest thanks.

On the Hirschl & Adler staff, I would like to acknowledge the efforts of Meredith Ward, whose

thorough research and write-up on the Samuel McIntire *Eagle* was most helpful, and James L. Reinish, who located a number of the works for this show. As always, Stuart Feld offered sound advice and support. At Hirschl & Adler Folk, Frank Miele, Marna Anderson, Bruce Bergmann, and Sally Hogin provided specific information on the works from that gallery.

Finally, there are two individuals who invariably make enormous contributions to our exhibition catalogues, but who are rarely recognized for them. Our photographer, Arthur Vitols, of Helga Photo Studios, patiently, tirelessly, and relentlessly photographed nearly every object in this exhibition, sometimes spending an hour or more to set up a particular shot. The success of his efforts is shown in the quality of the illustrations in this catalogue. And lastly, I want to thank Françoise Boas, of Colorcraft Lithographers, for putting all the pieces together in record time and producing such a beautiful catalogue.

March 16, 1989 Susan E. Menconi

WILLIAM RUSH (1756-1833)

1. Eagle

Carved wood, gessoed and gilded, 36 in. high x 68 in. wide x 61 in. long

Executed in 1811

RECORDED: Philip M. Isaacson, *The American Eagle* (1975), p. 95 fig. 96

EXHIBITED: Assembly Room, Independence Hall, Philadelphia, Pennsylvania, 1847-1914 // Pennsylvania Museum of Art, Philadelphia, 1937, *William Rush 1756-1833: The First Native American Sculptor* (text by Henri Marceau), pp. 30-31 no. 9 // Pennsylvania Academy of the Fine Arts, Philadelphia, 1982, *William Rush: American Sculptor* (text by Linda Bantel et al.), pp. 118, 123 no. 43 illus., 179, 205 no. 14 // Hirschl & Adler Galleries, New York, 1986, *From the Studio: Selections of American Sculpture 1811-1941*, pp. 8-9 no. 1 illus. in color

ON DEPOSIT: Historical Society of Pennsylvania, Philadelphia, 1983-86

EX COLL.: St. John's Evangelical Lutheran Church, Philadelphia, Pennsylvania, 1811-47; by gift to the City of Philadelphia, 1847-1914; returned to St. John's Church, 1914-86

William Rush carved this *Eagle* in 1811 for the old St. John's Evangelical Lutheran Church, built in 1808, on Race Street below Sixth Street, Philadelphia. The minutes of the April 6, 1811, Church Council meeting record its completion: "Mr. William Rush done the carving of the eagle. Cost $70" [quoted in Pennsylvania Museum of Art, *op. cit.*, p. 31]. The *Eagle*, an attribute of St. John the Evangelist, was placed high above the pulpit and held a chain in its mouth which was meant to appear to support the pulpit's sounding board, as shown in an 1829 watercolor by Reuben S. Gilbert of the interior of the church [*cf.* Pennsylvania Academy of the Fine Arts, *op. cit.*, p. 122 fig. 105].

The *Eagle* was given to the City of Philadelphia in 1847 and was installed in the Assembly Room at Independence Hall. According to Linda Bantel [*ibid.*, p. 123], the orb was probably added at this time. The sculpture was also displayed with a ribbon in its mouth, as seen in an 1856 chromolithograph of the setting [*ibid.*, p. 147 fig. 110].

The work was returned to St. John's Church in 1914. When the old church was demolished in 1924 and a new one was built in 1928-29 on Columbia Avenue near Sixty-first Street, the *Eagle* resumed its position high over the congregation.

This large, spirited, and completely documented sculpture is one of only two eagles that Linda Bantel fully accepts as the work of William Rush. The other, considerably smaller and without any early history, is ascribed to Rush mainly on its stylistic and technical relationship to the St. John's *Eagle*. It is in the collection of the Pennsylvania Academy of the Fine Arts, Philadelphia.

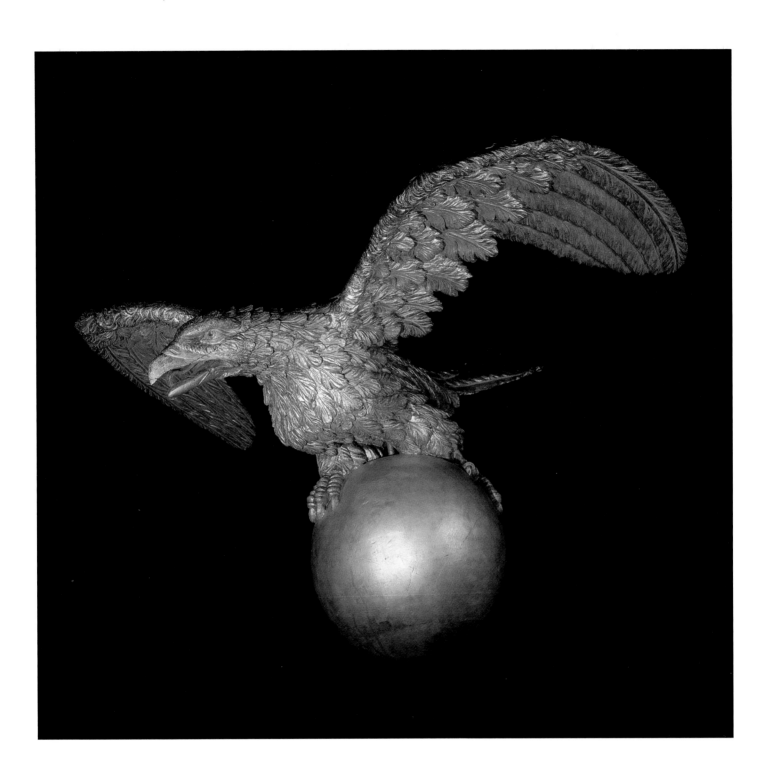

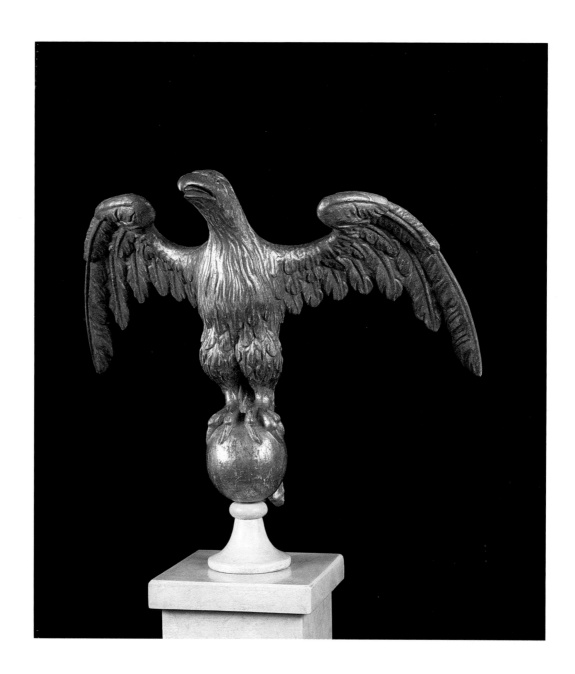

SAMUEL McINTIRE (1757-1811)

2. Eagle

Carved wood, gilded, on modern wood base, 15½ in. high (excluding base) x 18⅝ in. wide

Executed about 1804-05

EX COLL.: Richard Paine, Rockland, Maine, about 1950–until 1984; to [sale, Bruce Buxton, Portland, Maine, Aug. 10, 1984]; to private collection, until 1988

Architect, carver, and sculptor, Samuel McIntire was born in Salem, Massachusetts, and lived in or near Salem all his life. During his career he designed and built most of the important houses in that town, and, in his later years, was a sculptor in wood, executing several portrait busts and a group of carved eagles for the ornamentation of architecture and furniture.

This eagle is one of ten carved eagles that have been definitively ascribed to McIntire. It has been dated to about 1804-05 on stylistic grounds. Its original function is not known, since it is clearly too large to have been used on a piece of furniture and too small to have decorated a building. It is possible that it was carved as an ornament for a fence post, or on a large wall clock. In all respects it conforms to the style, period, and form of the other eagles that are documented by, or firmly attributable to, McIntire.

Of the nine other known McIntire eagles, seven are in the collection of the Essex Institute, Salem, Massachusetts, one is in the collection of the Lynn Historical Society, Massachusetts, and one is in a private collection, Massachusetts.

Two other eagles that may possibly have been carved by McIntire are in the collection of the Museum of Fine Arts, Boston, Massachusetts, and are discussed and illustrated in Richard Randall, *American Furniture in the Museum of Fine Arts, Boston* (1965), pp. 97-100 figs. 67 and 67a, 247-49 figs. 206 and 206a, the latter as attributed to John Doggett.

Nina Fletcher Little was the first to outline the unique characteristics of McIntire eagles that differentiate them from eagles by other carvers of the early nineteenth century. On the occasion of the McIntire Bicentennial Symposium in 1957 Little wrote: "The eagle perches on a large ball. Wings open but not upraised as if in flight. The greatest wing-spread is at top, with tips of wings slanted in toward body. The mouth is held open with protruding tongue and boldly curved beak. The body is short and plump with indented breast, and the bird stands upright on its supporting ball which it grasps in powerfully carved talons. The tail is attached to back of the ball and narrows in width behind the legs, but gains added strength by its unusual thickness. Carving of the bodies differs slightly in each example but the breast is usually striated rather than feathered, and the long wing feathers are expertly cut. Boldness of design and depth of carving are outstanding McIntire attributes" [Nina Fletcher Little, "Carved Figures by Samuel McIntire and his Contemporaries," in *Samuel McIntire: A Bicentennial Symposium, 1757-1957*, p. 78].

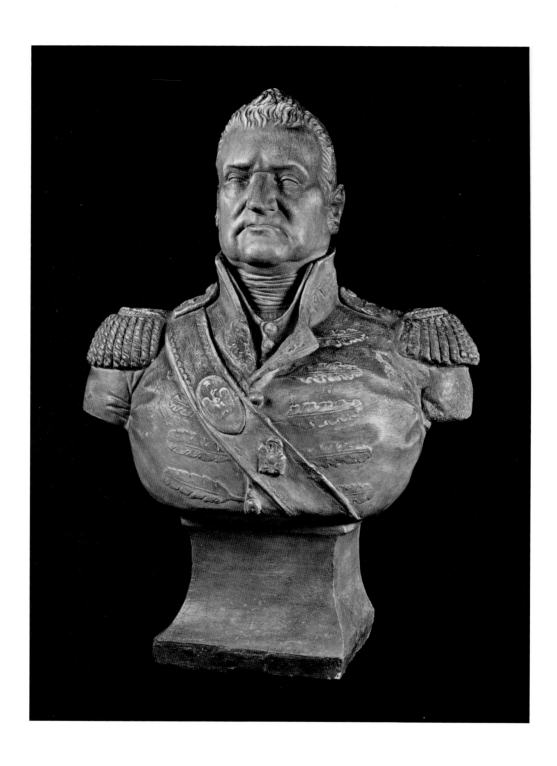

J.B. BINON (active in Boston, c. 1818-20)

3. Bust of Major General Henry Dearborn

Unfired clay, gessoed and painted, 28 in. high, on original wooden base, painted and marbleized, 41 in. high

Signed, dated, and inscribed (on proper right side): Binon de Lyons/Eleve de Chinard/ Boston 1818

RECORDED: *cf.* Letter, William Tudor to former President John Adams, Mar. 1819 (quoted in Andrew Oliver, *The Adams Papers: Portraits of John and Abigail Adams*, IV [1967], p. 181), writes: "I write this Letter to introduce Mr. Binon the Artist.... From the Specimens of his Abilities as an Artist of which we have satisfying Proof in a Bust of General Dearborn...." // *cf. Columbian Centennial* (about 1819, quoted in William T. Whitley, *Gilbert Stuart* [1932], p. 163), writes: "Mr. Binon was a pupil of the celebrated Chinard, and has hitherto done great honour to his instructor.... Since his arrival in this town [Boston] he has completed the marble busts of Mr. Adams and of General Dearborn...." // *cf.* Oliver, *op. cit.*, pp. 181, 184

EX COLL.: Lorenzo de Medici Sweat, Portland, Maine; to Mr. Clapp, Portland; to C.H. Robinson, Portland

Little is known about the life of the sculptor J.B. Binon. Originally from Lyons, France, he studied under the artist Joseph Chinard, after which he resided in Italy for eight years prior to his arrival in Boston around 1818. Binon is the first sculptor known to have worked in Boston. His best known sculpture is a marble bust of John Adams (The Boston Athenaeum, Massachusetts), of which several plasters were also made, but he is perhaps most remembered for his early influence on the important American neoclassical sculptor, Horatio Greenough.

The subject of this bust, Henry Dearborn, was born in North Hampton, New Hampshire, in 1751. He served as an army officer in the Revolutionary War in the battles of Bunker Hill, Ticonderoga, Valley Forge, and Yorktown, among others. He was a member of Congress from 1793 to 1797, where he served as an anti-Federalist Representative from the State of Massachusetts; he became Secretary of War under President Thomas Jefferson, from 1801 to 1809. In 1809 Dearborn was the Collector of the Port of Boston, and, in 1812, was appointed Major General of Militia and United States Marshall for the District of Maine, where he then made his home. He married his third wife, Sarah Bowdoin, widow of James Bowdoin III, in 1813.

Dearborn's last position, from 1822 to 1824, was as Minister to Portugal. He died in 1829.

In addition to this bust by Binon, Dearborn sat for a number of painters, notably, Charles Willson Peale, whose portrait of him, about 1796-97, is now in the collection of Independence National Historical Park, Philadelphia, Pennsylvania, and Gilbert Stuart, who painted Dearborn's portrait in 1812 (The Art Institute of Chicago, Illinois), as well as two replicas of the subject.

A photograph, taken prior to 1880, of the stair hall of the McClellan-Sweat Mansion, Portland, Maine (which subsequently became a part of the Portland Art Museum), shows this bust on the stair landing [Hirschl & Adler archives].

A marble version of the bust, also dated 1818, is in the collection of the Chicago Historical Society, Illinois.

HIRAM POWERS (1805-1873)

4. Proserpine (or **Persephone**)

Marble, 25 in. high

Signed and inscribed (on the back):
H. Powers sculp

Model executed in 1838-39

RECORDED: cf. Charles Edward Lester, *The Artist, The Merchant, and The Statesmen of the age of the Medici and of our own times* (1845), I, pp. 16, 17 // cf. Clara Louise Dentler, "White Marble: The Life and Letters of Hiram Powers" (unpub. ms., 1964, Hirschl & Adler Library), pp. 153-55 notes 1 and 2 // cf. Sylvia E. Crane, *White Silence: Greenough, Powers, and Crawford, American Sculptors in Nineteenth Century Italy* (1972), pp. 188 illus., 192, 199, also illus. on front dust cover // cf. Donald Martin Reynolds, "Hiram Powers and His Ideal Sculpture" (Ph.D. dissertation, Columbia University, New York, 1975; Garland reprint, 1977), pp. 1070-75

EXHIBITED: Hirschl & Adler Galleries, New York, 1986, *From the Studio: Selections of American Sculpture 1811-1941*, pp. 10-11 no. 2 illus. in color // Hirschl & Adler Galleries, 1988, *Adventure & Inspiration: American Artists in Other Lands*, pp. 30-31 no. 14 illus. in color

In ancient mythology, Proserpine (or Persephone), the maiden of spring, was the only daughter of Ceres, the goddess of corn or agriculture. Proserpine was carried off to the Underworld by its god Pluto for four months of the year, thereby causing winter, but was allowed to return to earth each spring.

Proserpine was one of Hiram Powers' first idealized busts, and, unlike such later works as *The Greek Slave* and *Eve Disconsolate*, was conceived only as a bust. The sculptor first referred to *Proserpine* in a letter dated November 5, 1838, to his friend and patron Nicholas Longworth of Cincinnati, as "a female head with a wreath of wheat in bloom crowning her hair, with acanthus leaves, emblem of immortality, around her waist" [quoted in Crane, *op. cit.*, p. 192]. The first marble of the subject, which was to become Powers' most popular work, was completed in 1839.

The sculptor later executed two variants. One, apparently unique, had a simulated wicker basket from which Proserpine's shoulders emerged; it was sold in 1845 to Edward L. Carey of Philadelphia (now, Philadelphia Museum of Art, Pennsylvania). The second, probably executed around

1853, had a simple leaf molding, such as Powers used in his busts of *The Greek Slave*, around the bottom of the figure.

Other examples of this work are in a number of museum and private collections, including those of Jo Ann and Julian Ganz, Jr., Los Angeles, California, The Baltimore Art Museum, Maryland, the Albright-Knox Art Gallery, Buffalo, New York, the Cincinnati Art Museum, Ohio, the Los Angeles County Museum of Art, California, and the Pitti Palace, Florence, Italy. The National Museum of American Art, Washington, D.C., has a plaster model for this bust.

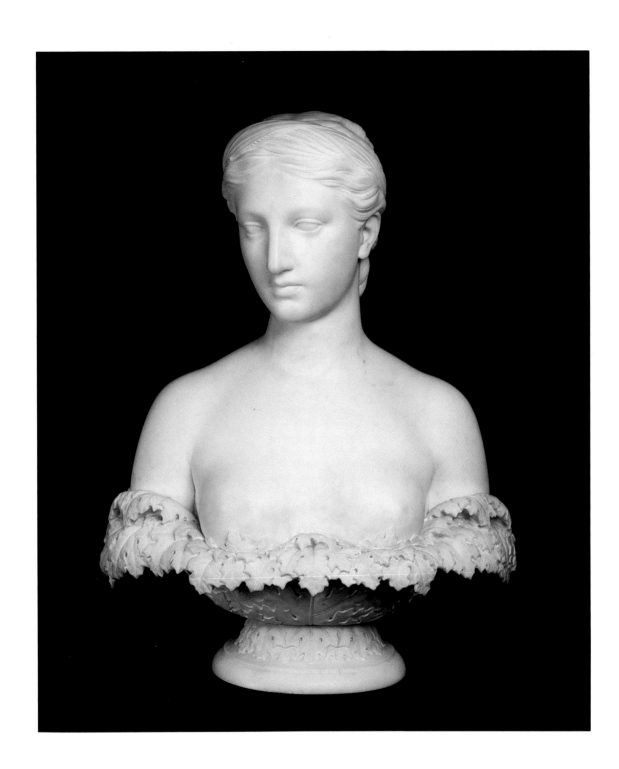

CHAUNCEY BRADLEY IVES (1810-1894)

5. Pandora

Marble, 65 in. high

Signed, dated, and inscribed (on the base):
C.B.IVES/FECIT. ROMAE.1858

Model executed in 1851

RECORDED: Chauncey Bradley Ives, "Note-books" (n.d., original sales lists) // "Chauncey B. Ives," in *Cosmopolitan Art Journal*, IV (Dec. 1860), pp. 163-64 // J. Beavington Atkinson, "International Exhibition, 1862, No. VII: English and American Sculpture," in *Art-Journal* (London), XXIV (Dec. 1862), p. 230 // W. Chaffers, *Catalogue of the Works of Antiquity and Art Collected by the Late William Henry Forman, Esq.* (1892, privately printed), no. 3786

EXHIBITED: London, England, 1862, *International Art Exposition: Roman School, Class XXXIX, Sculpture, Models, etc.*, no. 2657 // Hirschl & Adler Galleries, New York, 1988, *Adventure & Inspiration: American Artists in Other Lands*, pp. 38-39 no. 19 illus. in color

EX COLL.: the sculptor, until 1862; William Henry Forman, Esq., Pippbrook House, Dorking, England; to his estate, until 1890; to his nephew, Major Alexander Henry Browne, Callaly Castle, Alnwick, Northumberland, England; to his grandson, Major Alexander Simon Cadogan Browne, Callaly Castle, 1925-86

As told in ancient mythology, Pandora was sent by the gods to marry the earth-bound Titan Epimetheus, whose brother Prometheus had angered Zeus. Pandora was given a casket—or box—filled with both good and evil, and instructed not to open it. But curiosity got the better of her and she lifted the lid, thereby releasing not only the good gifts, but the evils as well. In horror, she clamped the lid shut, managing to trap hope, which clung to the rim of the box, so that mankind would be able to endure its misfortunes.

Widely considered to be the sculptor's masterpiece, *Pandora* was initially modeled in clay in 1851. It was Ives' first major life-size ideal piece, and his first sculpture of the female nude. It was soon recognized by contemporary critics as one of the most graceful and classically pure statues of its day, and was hailed for its subtle expression of a combination of emotions—both curiosity and doubt—shown not only in Pandora's face, but in her pose as well.

Three life-size examples of the subject were carved in marble during the 1850s. These are: one executed in 1851 for Ives' important early patron, Major Philip Kearney of New York and New Jersey (unlocated); another carved in 1854 for John B. Latrobe of Baltimore, Maryland (Virginia Museum of Fine Arts, Richmond); and the present work of 1858, which stood in Ives' studio until it was shown at the *International Art Exposition* of 1862, London, and sold out of that exhibition, presumably directly to William Henry Forman.

The sculpture was inspired in part by the immensely popular and famous *Greek Slave* by Hiram Powers, which had recently completed a two-year tour of the United States. It was inevitable that *Pandora* would be compared with its more famous predecessor, and it fared rather well in the opinions of the critics. One author, writing in *Cosmopolitan Art Journal*, IV (Dec. 1860), p. 164, stated: "Compared with, for instance, the 'Greek Slave' of Hiram Powers, [*Pandora*] is equal to it in anatomical symmetry, superior to it in grace and disposition, and much above it in ideality and power of rendering emotion."

Even though *Pandora* received wide critical acclaim when it appeared in 1862 at the London Exposition, Ives reworked the model in 1863, making changes in the tilt of the head, the position of the right hand, and the shape of the box that the figure is holding. In all, nineteen marble replicas of the subject were made, the last as late as 1891. Unlike the 1851 model, however, the later version was carved in several (possibly as many as five) different sizes. Examples of the later variant may now be found in the collections of the Detroit Institute of Arts, Michigan; the City of Bridgeport, Connecticut (on deposit with the National Museum of American Art, Washington, D.C.); The Brooklyn Museum, New York; the Museum of Fine Arts, Boston, Massachusetts; the St. Johnsbury Athenaeum, Vermont; the Passaic County Historical Association, Paterson, New Jersey; The Chrysler Museum, Norfolk, Virginia; and the High Museum of Art, Atlanta, Georgia.

The sculpture retains its original marble pedestal, which measures 25½ inches high.

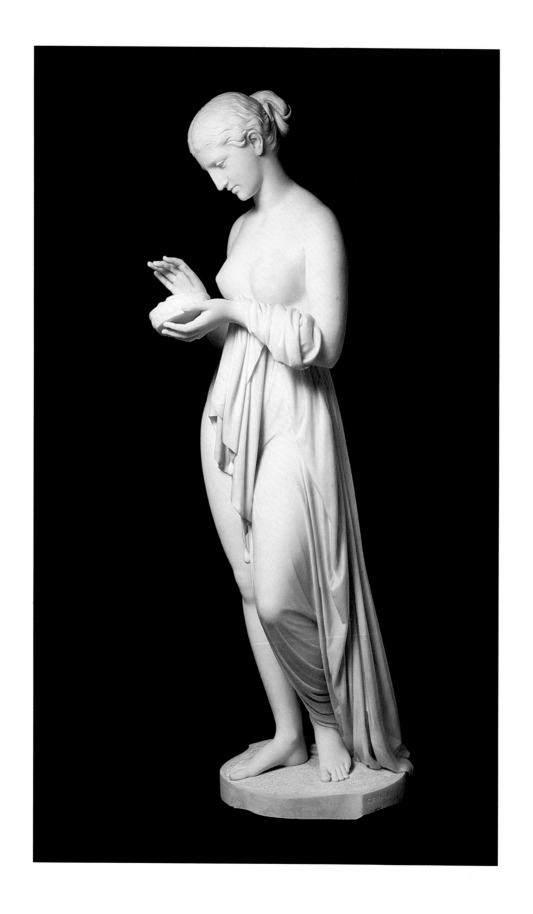

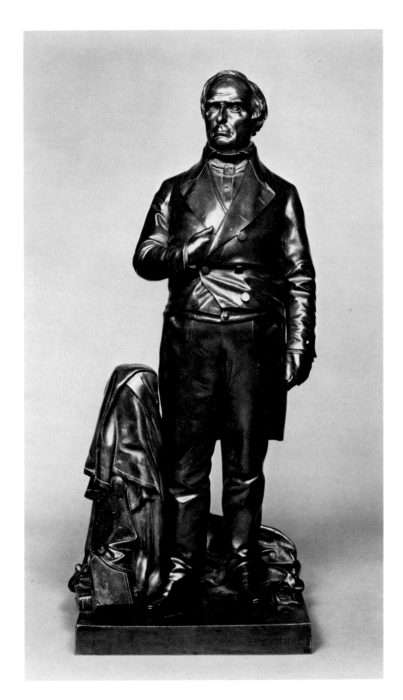

THOMAS BALL (1819-1911)

6. Daniel Webster

Bronze, dark brown patina, 29⅞ in. high

Signed, dated, and inscribed (on the base): T Ball Sculpt/Boston Mass/1853/Patent assigned to/C W Nichols

Founder's mark (on the base): J.T. AMES/ FOUNDER/CHICOPEE/MASS/47

RECORDED: *cf. Thomas Ball, My Threescore Years and Ten* (1891), pp. 141-42 // *cf.* Wayne Craven, "The Early Sculptures of Thomas Ball," in *North Carolina Museum of Art Bulletin*, V (Fall 1964/Winter 1965), pp. 6, 7 fig. 4, 8 // *cf.* Lewis I. Sharp, *New York City Public Sculpture by 19th-Century American Artists* (1974, The Metropolitan Museum of Art, New York), p. 45

Thomas Ball began his artistic career as a painter, but by 1850 had turned his attention to sculpture. He was fascinated by the "god-like" head of Daniel Webster, the Massachusetts statesman and orator, and in 1851-52 carved a cabinet-sized bust of him. Dissatisfied with the results, Ball destroyed the small bust, but almost immediately began a second portrait of him, which he completed a few days before Webster's death and which attracted considerable attention.

With talk of a possible commission for a statue of Webster in Boston, Ball modeled this, his first full-length figure, in 1853. Although the Boston commission ultimately went to Hiram Powers, Ball sold the Webster statuette for $500.00 on the first day it was exhibited. The work was purchased, together with the rights to reproduction, by the art dealer C.W. Nichols, hence the inscription: "Patent assigned to C W Nichols." This bronze, produced by the J.T. Ames Foundry, Chicopee, Massachusetts, is among the earliest bronzes to be cast in America.

Many years later the sculptor was commissioned to create a fourteen-foot enlargement of this sculpture for Central Park, New York. The monument was officially dedicated in 1876, and remains to this day as a prominent ornament along the 72nd Street transverse.

Other examples of this bronze are in the collections of The White House, Washington, D.C., The Metropolitan Museum of Art, New York, The North Carolina Museum of Art, Raleigh, The New-York Historical Society, New York, The Newark Museum, New Jersey, and the U.S. Capitol, Washington, D.C.

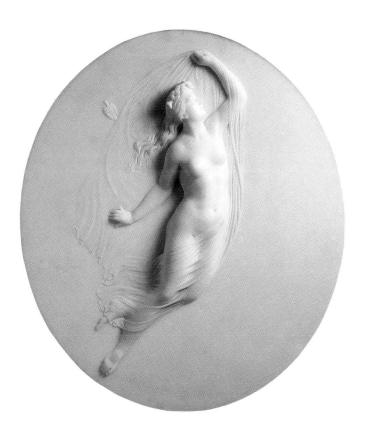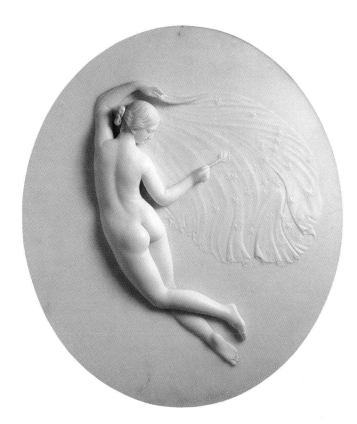

WILLIAM HENRY RINEHART
(1825-1874)

7. Morning and **Evening**

Marble reliefs, each 24½ x 21⅞ in. (oval)

Each signed, dated, and inscribed (at lower center): WM. H. RINEHART. SCULPT. ROME. 1874

Models executed by 1856

RECORDED: *cf.* Marvin Chauncey Ross and Anna Wells Rutledge, *A Catalogue of the Work of William Henry Rinehart, Maryland Sculptor, 1825-1874* (1948), pp. 28-29 no. 27, [n.p.] pl. III // *cf.* William H. Gerdts, *American Neoclassic Sculpture: The Marble Resurrection* (1973), pp. 86-87 nos. 68 and 69 illus.

EXHIBITED: Hirschl & Adler Galleries, New York, 1988, *Adventure & Inspiration: American Artists in Other Lands*, p. 50 no. 29 illus. in color

According to Ross and Rutledge [*loc. cit.*], *Morning* and *Evening* were originally commissioned by Augustus J. Albert, whose pair, dated 1856, is now in the collection of the Peabody Institute of Johns Hopkins University, Baltimore, Maryland. Seven additional pairs were carved in the years between 1856 and 1874, as well as a single version of *Morning*. This pair, which is dated 1874, was almost certainly carved either for Thomas Vaughn or E.C. Peters, both of whom ordered marbles from the sculptor in 1874 and whose examples were listed in the inventory of the contents of the Rinehart studio compiled right after the sculptor's death.

About *Morning* and *Evening*, which he considered to be "among the most beautiful figures in American neoclassicism," William H. Gerdts wrote [*loc. cit.*]: "The sources for these paired reliefs can be found in the figures of *Night* and *Morning* by the great patriarch of neoclassic sculpture, Bertel Thorwaldsen. These were probably the most famous relief sculptures of the nineteenth century, and reproductions and engravings after them found their way into many American homes. They were reproduced in shell, in gems, in plaster, and in bronze, and it is not surprising that American sculptors working in the neoclassic idiom both in Italy and back home tried to rival the Danish master."

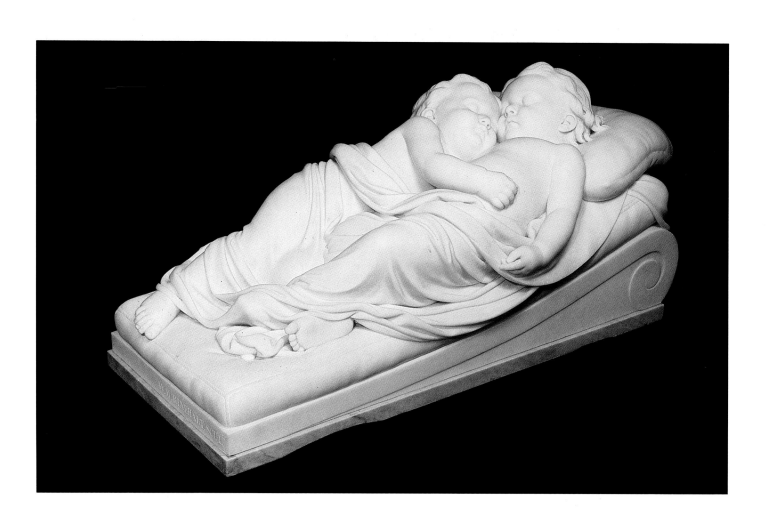

WILLIAM HENRY RINEHART
(1825-1874)

8. Sleeping Children

Marble, 14½ in. high x 35½ in. long x 18⅞ in. deep

Signed and inscribed (on the base):
W. H. RINEHART. SCULPT

Model executed in 1859

RECORDED: *cf.* Marvin Chauncey Ross and Anna Wells Rutledge, *A Catalogue of the Work of William Henry Rinehart, Maryland Sculptor, 1825-1874* (1948), pp. 33-35 no. 34, [n.p.] pl. VIII // *cf.* Kathryn Greenthal, Paula Kozol, and Jan Seidler Ramirez, *American Figurative Sculpture in the Museum of Fine Arts, Boston* (1986), pp. 150-52 no. 50 illus.

EXHIBITED: Hirschl & Adler Galleries, New York, 1988, *Adventure & Inspiration: American Artists in Other Lands*, p. 51 no. 30 illus. in color

EX COLL.: private collection, Shropshire, England, about 1925–until 1987

Originally conceived in 1859, *Sleeping Children* became Rinehart's most popular work. According to the Rinehart studio records, approximately nineteen examples of the subject were carved in marble. Traditionally it has been thought that the piece was modeled at the request of Mr. and Mrs. Hugh Sisson of Baltimore, Maryland, who received the first marble of the subject and were early patrons of Rinehart's, also commissioning from him portrait busts of themselves.

The theme in sculpture of slumbering children was extremely popular during the nineteenth century, and Rinehart's depiction finds several contemporary prototypes, including Thomas Crawford's *Babes in the Woods* of 1851 (The Metropolitan Museum of Art, New York), William Geef's *Paul et Virginie*, also of 1851 (Royal Collection, Osborne House, Isle of Wight), and Sir Francis Chantrey's tomb effigy of the Robinson sisters of 1817 (Lichfield Cathedral, England), all of which would have been known to Rinehart. The popularity of the sleeping babies motif was due in part to its ambiguous meaning. In Rinehart's work it is not clear whether the children are merely napping—a Victorian symbol for youth's innocence and purity—or if they are sleeping the eternal slumber of death. The lifelike fleshiness of the babies' skin and the informality of their pose suggest that they might wake at any moment, yet their stillness and the coldness of the marble convey a sense of permanence [Ramirez, *loc. cit.*].

This version of *Sleeping Children*, with its history of ownership in Shropshire, England, in this century, is very likely the one listed in Ross and Rutledge [*op. cit.*, no. 34c] as having been carved in 1866 for Timothy Kendrick and later passed to Sir George Kendrick of Birmingham, England. The Sisson example was used eventually as a memorial in the Sisson plot, Greenmount Cemetery, Baltimore, where it remains in much-weathered condition today. Other versions may now be found in the collections of Yale University Art Gallery, New Haven, Connecticut, the Museum of Fine Arts, Boston, Massachusetts, the Munson-Williams-Proctor Art Institute, Utica, New York, the National Museum of American Art, Washington, D.C., and the Wadsworth Atheneum, Hartford, Connecticut.

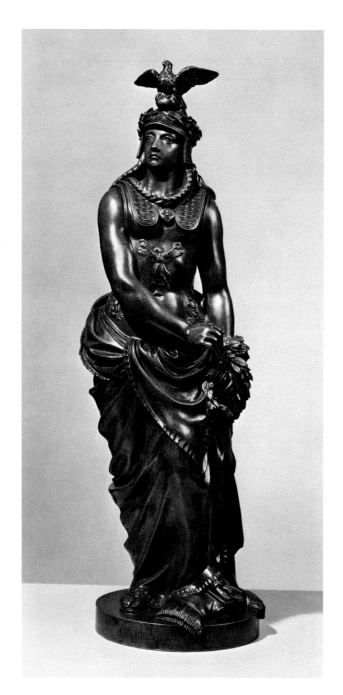

JAMES HENRY HASELTINE (1833-1907)

9. America Victorious

Bronze, medium brown patina, 16¾ in. high

Signed and inscribed (on the base): J HENRY HASELTINE FT. ROME

Titled (on the base): AMERICA VICTORIOUS

Model executed about 1876

EXHIBITED: Hirschl & Adler Galleries, New York, 1988, *Adventure & Inspiration: American Artists in Other Lands*, p. 67 no. 43 illus.

The brother of the painter William Stanley Haseltine and uncle to the sculptor Herbert Haseltine, James Henry Haseltine was a native of Philadelphia, Pennsylvania. James studied sculpture there under Joseph A. Bailly, and exhibited works—apparently, mostly in marble—at the Pennsylvania Academy of the Fine Arts beginning in 1855. He went to Italy and France for further study about 1857, but returned in 1861 to serve for two years in the Civil War. After the war he again went abroad and opened a studio in Rome, where he was to spend the rest of his life.

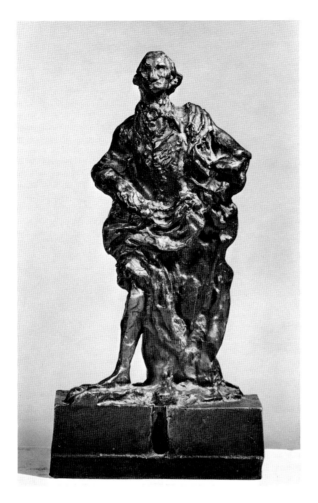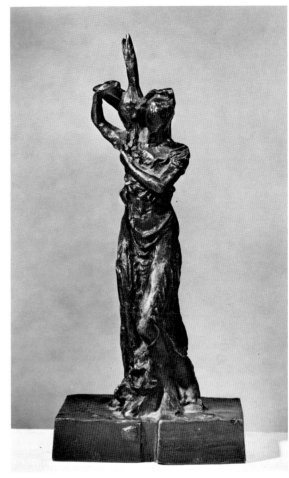

THOMAS EAKINS (1844-1916)

10a. George Washington

Bronze, dark brown patina, 8 in. high

Model executed about 1877

10b. Nymph with Bittern

Bronze, dark brown patina, 9⅛ in. high

Model executed about 1877

RECORDED: *cf.* Phyllis D. Rosenzweig, *The Thomas Eakins Collection of the Hirshhorn Museum and Sculpture Garden* (1977), pp. 72-73 nos. 27 and 28 illus. // *cf.* Theodore Siegl, *The Thomas Eakins Collection: The Philadelphia Museum of Art* (1978), pp. 67-69 nos. 26A and 26D illus., 167 nos. 1A and 1D

EXHIBITED: (*Nymph with Bittern* only) Yale University Art Gallery, New Haven, Connecticut, 1968, *American Art from Alumni Collections*, [n.p.] no. 95 illus., lent by Mr. and Mrs. Leonard Baskin

EX COLL.: Mr. and Mrs. Leonard Baskin,

Leeds, Massachusetts, about 1965–until 1982

These bronzes represent two of six studies, of which five remain extant, that Eakins made for his 1877 painting titled *William Rush Carving his Allegorical Figure of the Schuylkill River* (Philadelphia Museum of Art, Pennsylvania). The other three in the series represent the *Head of William Rush*, the *Head of the Model*, and *The Schuylkill Freed*. The five in this set, together with four studies of horses that Eakins made for his 1879 painting titled *The Fairman Rogers Four-in-Hand* (Philadelphia Museum of Art), are the only surviving three-dimensional, free-standing sculptures by the artist.

These two bronzes were cast from plasters formerly in the collection of Seymour Adelman (a personal friend of Mrs. Eakins, from whom he almost certainly acquired them) and now in the collection of Mr. and Mrs. Daniel Dietrich II. Adelman owned three plasters (*George Washington*, *Nymph with Bittern*, and *Head of William Rush*), from which

three sets of bronzes were cast around 1965.

The plaster models for these works—and the other three in the series—were cast in 1931 by Mrs. Thomas Eakins and Samuel Murray from the wax and wood originals now in the collection of the Philadelphia Museum of Art. Several sets of plasters were made at that time. Other plasters are in the Philadelphia Museum (all five subjects), The Newark Museum, New Jersey (all five), the Hirshhorn Museum and Sculpture Garden, Washington, D.C. (*Nymph with Bittern*, *George Washington*, and *The Schuylkill Freed*), and The Joslyn Art Museum, Omaha, Nebraska (*Nymph with Bittern*).

Other bronzes are in the following collections: Yale University Art Gallery, New Haven, Connecticut (*Nymph with Bittern* and *Head of William Rush*) and Bryn Mawr College, Pennsylvania (*Nymph with Bittern*, *George Washington*, and *Head of William Rush*). Those at Bryn Mawr were bequeathed by Seymour Adelman.

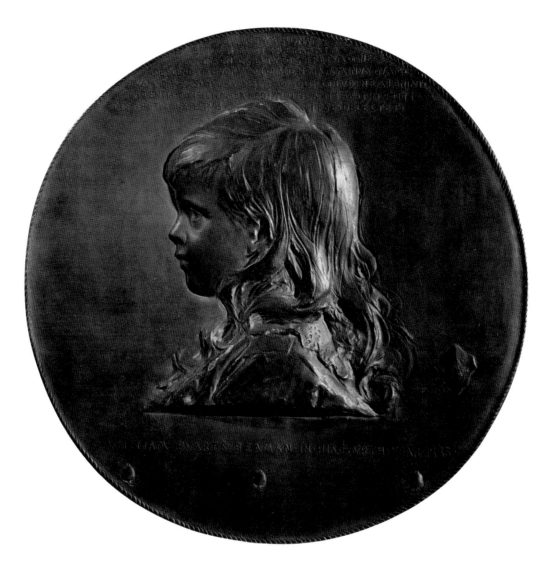

AUGUSTUS SAINT-GAUDENS
(1848-1907)

11. William E. Beaman

Bronze relief, dark brown patina, 18½ in.
(diameter)

Signed with artist's monogram and inscribed
(at center right): ASG/FECIT

Inscribed and dated (across bottom):
•WILLIAM•EVARTS•BEAMAN•IN•HIS•
FOVRTH•YEAR•1885•

Inscribed with a verse from Book IX of Sen-
eca's *Dialogues* (across top): QVANTVM•
BONVM•/EST• VBI•SVNT PRAEPARATA•/PEC-
TORA IN QVAE• TVTO•SECRETVM OMNE/
DESCENDAT•QVORVM•CONSCIENTIAM•
MINVS•QVAM•/TVAM DIM EAS•QVORVM•
SERMO•SOLLICITVDINEM•LENIAT/SENTEN-
TIA•CONSILIVM•EXPEDIAT• HILARITAS•TRI-
STITIAM/DISSIPET CONSPECTVS• IPSE•

DELECTET• [How good it is to have willing
hearts as safe depositories for your every
secret, whose privity you fear less than your
own, whose conversation allays your anxiety,
whose counsel promotes your plans, whose
cheerfulness dissipates your gloom, whose
very appearance gives you joy]

Founder's mark (along rim, at the bottom):
GORHAM CO FOUNDERS

RECORDED: *cf.* John H. Dryfhout, *The Work
of Augustus Saint-Gaudens* (1982), p. 149 no.
116 illus.

EX COLL.: William Evarts Beaman (1881-
1945); to his son, Charles Cotesworth
Beaman; to his widow, Mrs. Charles C.
Beaman, until 1986

The subject of this portrait, William Evarts
Beaman (1881-1945), was the son of Charles
C. and Hettie Beaman from whom Saint-

Gaudens rented the Cornish, New Hamp-
shire, house that he would eventually pur-
chase. That property is now the Saint-
Gaudens National Historic Site. The relief
of *William E. Beaman* was modeled in 1885,
the first summer that Saint-Gaudens spent at
Cornish, and was presented to the Beamans
in lieu of rent for that year.

This bronze was cast under the direction of
Saint-Gaudens' widow as a second example
for the Beaman family. The original example
remains in the sitter's family; another bronze
of the subject, together with the plaster
model, is in the collection of the Saint-Gaud-
ens National Historic Site.

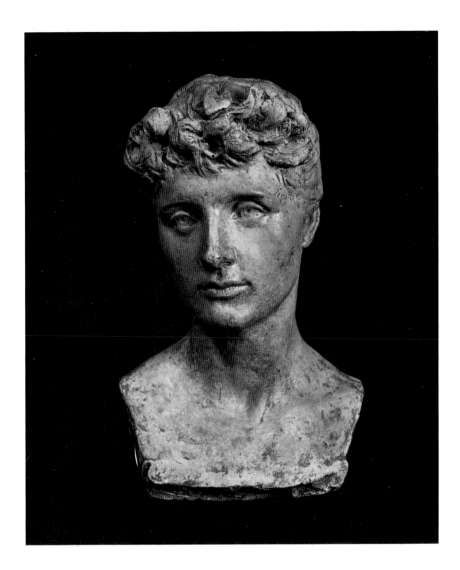

AUGUSTUS SAINT-GAUDENS
(1848-1907)

12. Bust of Davida Johnson Clark

Plaster, patinated, 10½ in. high

Executed in 1886

RECORDED: John H. Dryfhout, *The Work of Augustus Saint-Gaudens* (1982), p. 154 no. 120, listed as "unlocated, original plaster (?) (before 1928, in the Clark Family Collection, San Diego, California)"

EX COLL.: the sculptor; by gift to the sitter, Davida Johnson Clark; to their son, Louis Paul Clark; to his son, Louis John Clark; to his widow, Mrs. June Clark Moore

John Dryfhout wrote about this work [*loc. cit.*]:

> This bust . . . is an early study for the head of *Diana*. . . . Davida Johnson Clark (died 1910) was an artist's model who posed for Augustus Saint-Gaudens and later became his mistress and the mother of their son. . . . The plaster served as a study not only for the *Diana* head but also for the *Amor Caritas*. . . .

This is the only known plaster of this image. A marble carving of the head is in the collection of the Saint-Gaudens National Historic Site, Cornish, New Hampshire. A terra-cotta example, formerly with the Piccirilli Studios, undoubtedly served as the guide for the stone cutters who roughed out the marble bust (now, private collection, Arkville, New York).

AUGUSTUS SAINT-GAUDENS
(1848-1907)

13. Robert Louis Stevenson

Bronze relief, dark brown patina, 17½ in.
(diameter)

Signed (at upper right): AUGUSTUS/SAINT-
GAUDENS

Inscribed (at upper left): TO ROBERT LOUIS/
STEVENSON

Inscribed and dated (at upper center, and left
center): YOUTH NOW FLEES ON FEATHERED
FOOT/FAINT AND FAINTER SOUNDS THE
FLUTE/RARER SONGS OF GODS AND STILL/
SOMEWHERE ON THE SUNNY HILL/OR ALONG
THE WINDING STREAM/THROUGH THE
WILLOWS FLITS A DREAM/FLITS BUT SHOWS A
SMILING FACE/FLEES BUT WITH SO QUAINT A
GRACE/NONE CAN CHOOSE TO STAY AT
HOME/ALL MUST FOLLOW ALL MUST ROAM//
THIS IS UNBORN BEAUTY SHE/NOW IN AIR
FLOATS HIGH AND FREE/TAKES THE SUN AND
BREAKS THE BLUE/LATE WITH STOOPING
PINION FLEW/RAKING HEDGEROW TREES
AND WET/HER WING IN SILVER STREAMS AND
SET/SHINING FOOT ON TEMPLE ROOF/NOW
AGAIN SHE FLIES ALOOF/COASTING MOUN-
TAIN CLOUDS AND KISS'T/BY THE EVENING'S
AMETHYST//IN WET WOOD AND MIRY LANE/
STILL WE PANT AND POUND IN VAIN/STILL
WITH LEADEN FOOT WE CHASE/WANING PIN-
ION FAINTING FACE/STILL WITH GREY HAIR
WE STUMBLE ON/TILL BEHOLD THE VISION
GONE/WHERE HATH FLEETING BEAUTY LED/
TO THE DOORWAY OF THE DEAD/LIFE IS OVER
LIFE WAS GAY/WE HAVE COME THE PRIMROSE
WAY//MDCCCLXXXVII [1887]

Inscribed (at lower center): COPYRIGHT BY A
SAINT GAVDENS

Model executed in 1887-88

RECORDED: *cf.* Homer Saint-Gaudens, ed.,
The Reminiscences of Augustus Saint-Gaudens
(1913), I, pp. 367, 373-89, II, 125-29, 227,
297 // *cf.* National Portrait Gallery, Washing-
ton, D.C., *Augustus Saint-Gaudens: The Por-
trait Reliefs* (1969, text by John H. Dryfhout
and Beverly Cox), nos. 39-41 // *cf.* John H.
Dryfhout, "Robert Louis Stevenson," in
Metamorphoses in Nineteenth Century Sculpture
(1975), pp. 187-200 fig. 9 // *cf.* John H.
Dryfhout, *The Work of Augustus Saint-Gaudens*
(1982), pp. 174-76 no. 133, various versions
illus., see also pp. 173-74 no. 132 illus.,
261-63 no. 188 illus.

When Saint-Gaudens first read Robert Louis
Stevenson's *New Arabian Nights*, he was so
taken by the poet's work that he declared:
". . . if Stevenson ever crossed to this side of
the water I should consider it an honor if he
would allow me to make his portrait"
[quoted in Saint-Gaudens, *op. cit.*, I, p. 373].
When Stevenson came to America in 1887,
the painter Will H. Low arranged an intro-
duction between the two at the Hotel Albert,
New York, where Stevenson and his wife
were staying. The poet and sculptor liked
each other immediately, and five sittings for
the portrait took place at the hotel, with Ste-
venson propped up in bed due to his tuber-
cular condition. Stevenson left for Saranac in
the Adirondack Mountains, New York, soon
thereafter for medical treatments, but was
back in New York during the spring of 1888,
at which time further sittings took place.

The first version of the *Robert Louis Stevenson*
was rectangular, but Saint-Gaudens later
adapted it to this circular format. Originally
three feet in diameter, the circular version
was reduced to two sizes, the present one
and another measuring approximately 12
inches in diameter. (Some years later, in
1894, when Saint-Gaudens was commis-
sioned to create a memorial to Stevenson for
the Church of St. Giles, Edinburgh,
Scotland, he reworked the rectangular com-
position.) Throughout the production of the
piece in its various forms, particularly in the
circular versions, Saint-Gaudens continued
to make subtle revisions in the model by
changing the drapery, the configuration of
the bedpost, the inscription, and other
details.

The verses inscribed on the relief are from
Stevenson's *Underwoods* collection (1887),
which was dedicated to Will H. Low.

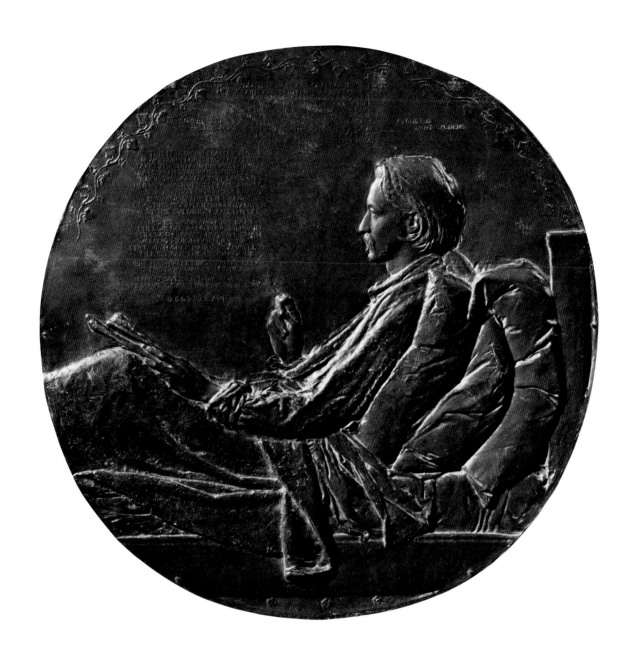

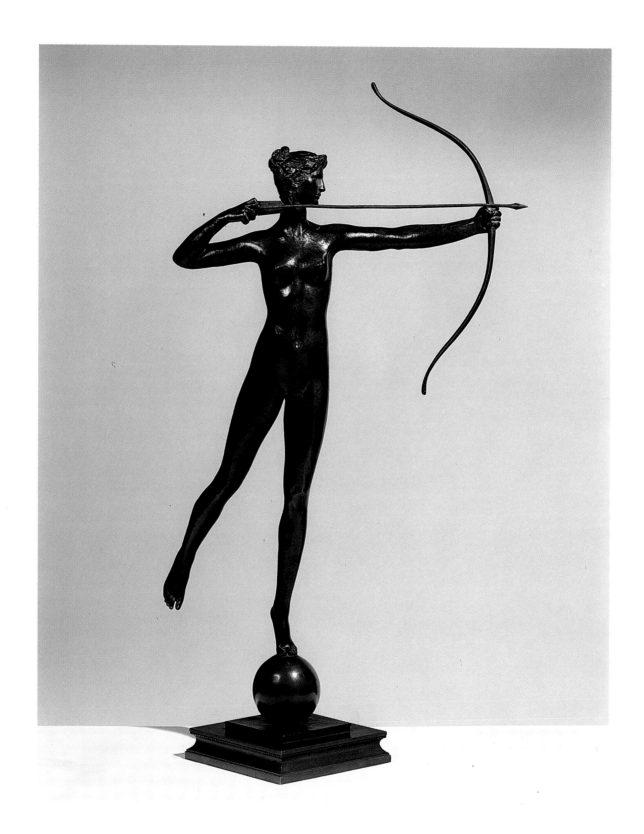

AUGUSTUS SAINT-GAUDENS
(1848-1907)

14. Diana

Bronze, dark brown patina, 28¼ in. high
(overall), 21½ in. high (figure alone)

Signed and dated (on the base): AVGVSTVS.
ST.GAVDENS/1894

Founder's seal (on the base): E. GRUET/
JEUNE/FOUNDER/44 BIS AVENUE DE
CHATILLON/PARIS

Model executed in 1892-94

RECORDED: *cf.* John H. Dryfhout, "Diana,"
in *Metamorphoses in Nineteenth Century Sculpture* (1975), pp. 201-13, another example of
this variant illus. p. 208 no. 38 // *cf.* John H.
Dryfhout, *The Work of Augustus Saint-Gaudens*
(1982), pp. 205-10, another example of this
variant illus. p. 208 no. 154-6, see also pp. 155
no. 121 illus., 194 no. 144 illus.

EX COLL.: Perkins family, Boston, Massachusetts, by 1922; by descent to Mrs. Palfrey
Perkins, Boston, until 1988

The monumental statue of *Diana*, Saint-Gaudens' only nude figure, was originally
conceived in 1886 as a gilded copper weathervane for the top of the tower of Madison
Square Garden, New York, designed by the
architect Stanford White. Upon its installation in 1891, however, both White and Saint-Gaudens recognized that the eighteen-foot
figure was poorly balanced and too large in
scale for the settting. (In 1892 it was removed
from the site, and in 1893 was installed atop
McKim, Mead, and White's pavilion at the
World's Columbian Exposition, Chicago,
Illinois, where it was almost completely
destroyed in a fire.) Saint-Gaudens then
reworked the figure, making changes in the
drapery and other details and reducing its
height to approximately thirteen feet. The
new *Diana* was installed in 1894 and
remained in place until 1925 when Madison
Square Garden was torn down. After residing
in storage for several years, it entered the
collection of the Philadelphia Museum of
Art, Pennsylvania, in 1932, where it remains
today.

Saint-Gaudens began producing bronze
reductions of the *Diana* almost immediately
after the second monumental version was
installed. These reductions, which were
modeled by hand and not mechanically
reproduced, were made in two sizes. The
"large Diana" measures approximately 31 in.
high (figure only), and the "small Diana,"
21½ in. (figure only). This work, an example
of the "small Diana," is the first of two variations of the figure in this scale, and was
almost certainly cast into bronze by 1899.

Other examples of this version of the "small
Diana" are in the collections of the Nichols
House Museum, Boston, Massachusetts,
The Metropolitan Museum of Art, New York
(gilded), and a private collection, Brookline,
Massachusetts (slightly different base and
bow).

The previous owner of this bronze, Mrs. Palfrey Perkins, stated that the *Diana* had been
in the family of her late husband at least since
1922, the year of her marriage, and probably
since the work had been cast many years
earlier.

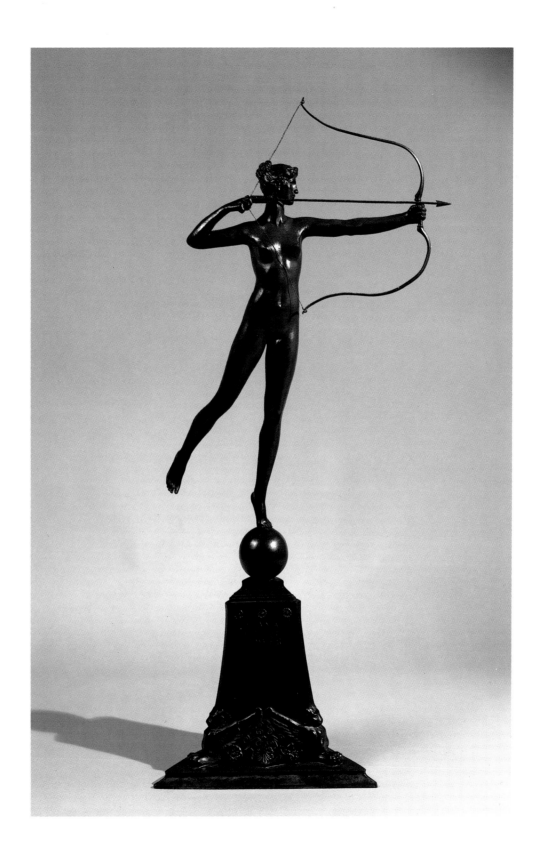

AUGUSTUS SAINT-GAUDENS
(1848-1907)

15. Diana of the Tower

Bronze, dark brown patina, 39 in. high (overall), 21½ in. (figure alone)

Signed, dated, and inscribed, with copyright date (on the base): © A SAINT GAUDENS/ MDCCCXCV [1895]

Signed and dated, with date of this version (on the base): AVGVSTVS/SAINT GAVDENS/ MDCCCXCIX [1899]

Inscribed (on the base): DIANA/OF THE/ TOWER

Founder's seal (on the base): E. GRUET [illeg.]

Model executed in 1892-94

RECORDED: cf. John H. Dryfhout, "Diana," in *Metamorphoses in Nineteenth Century Sculpture* (1975), pp. 201-13, another example of this variant illus. p. 210 no. 39 // cf. John H. Dryfhout, *The Work of Augustus Saint-Gaudens* (1982), pp. 205-10, another example of this variant illus. p. 209 no. 154-7, see also pp. 155 no. 121 illus., 194 no. 144 illus.

EX COLL.: [Doll & Richards, Boston, Massachusetts]; to a member of the Adams Family, Massachusetts; by descent in the family to a private collection, Lincoln, Massachusetts, until 1988

Whereas the previous entry (cat. no. 14) represents the first variant of Saint-Gaudens' "small Diana," this bronze is an example of the second. It differs from the earlier version most notably in its Renaissance-style tripod base, decorated with griffin heads and inscribed "Diana of the Tower," and in the configuration of the bow.

Saint-Gaudens first discussed this variant of his "small Diana" in a letter dated August 3, 1899 to his wife. The sculptor, who was then on an extended stay in Paris, mentioned the new pedestal and added that he had "remodeled the bow and hair carefully." Later that year, on November 28, 1899, he wrote to his Boston dealers, Doll & Richards, to inform them of the changes and to suggest that they raise the price [both quoted in Dryfhout, "Diana," *op. cit.*, p. 209]:

> As you will see I have had a new pedestal for the small Dianas and an entirely new model. This has added a good deal to the expense of production and if you think it could be done I should like to have the price raised to $175.00.

The fact that Saint-Gaudens knew that the second "small Diana" was more expensive to produce (the first variant was sold at Doll & Richards for $150.00) indicates that bronzes of this type were already being cast by November 1899.

Other bronzes of this version of the "small Diana" are in the collections of the Cleveland Museum of Art, Ohio, the Currier Gallery, Manchester, New Hampshire, the Gilcrease Institute of History and Art, Tulsa, Oklahoma, the New-York Historical Society, New York, the New York Life Insurance Company, New York, Smith College Museum of Art, Northampton, Massachusetts, the Virginia Museum of Fine Arts, Richmond, Williams College, Williamstown, Massachusetts, and a private collection, New York. Other examples, which appear to be identical to this in all but a slightly modified hair style, are in the National Gallery of Art, Washington, D.C., and a private collection, Santa Fe, New Mexico.

AUGUSTUS SAINT-GAUDENS
(1848-1907)

16. Amor Caritas

Bronze relief, dark green patina, 37⅞ x 18 in.
(excluding frame)

Signed and dated (at lower left): •AVGVSTVS•/
SAINT GAVDENS/MDCCCXCVIII [1898]

Inscribed (at lower center): IN MEMORY OF/
NANCY•LEGGE•WOOD•HOOPER/MDCCCXIX-
MDCCCXCVIII [1819-1898]

Inscribed on tablet (at upper center): •AMOR•
CARITAS• [Love-Charity]

RECORDED: cf. John H. Dryfhout, *The Work
of Augustus Saint-Gaudens* (1982), pp. 234-35
no. 169 illus.

EX COLL.: By gift in memory of Nancy
Legge Wood Hooper to the Unitarian Soci-
ety, Fall River, Massachusetts, shortly after
1898–until 1986

The motif of a standing, classically-draped
female figure was to preoccupy Saint-Gaud-
ens throughout his career. He first took up
the idea in 1879-80 with his commission for
the tomb of Edwin D. Morgan, Cedar Hill
Cemetery, Hartford, Connecticut (destroyed
by fire before its completion in marble), and
returned to it periodically all his life. None of
the female figures he depicted, however, is
as beautifully realized or, indeed, as arrest-
ing as his 1898 *Amor Caritas*, which repre-
sents the finest example of this form. As in a
number of other works, including the *Diana*
(cat. nos. 14 and 15), Davida Johnson Clark,
Saint-Gaudens' mistress and favorite model,
posed for *Amor Caritas*.

The large bronze of *Amor Caritas* (102½ x
48 in.) was exhibited at the Exposition Uni-
verselle, Paris, in 1900, along with several
other works by the sculptor, and won him the
Grand Prize. The French Government pur-
chased it for the Luxembourg Museum,
Paris, which was an extraordinary honor for
an American at that time. In recognition of
his talents and his stature in contemporary
sculpture, Saint-Gaudens was made a corre-
sponding member of the Société des Beaux-
Arts, and named an officer of the Legion of
Honor.

Saint-Gaudens produced approximately
twenty reductions in bronze of the model,
including this example, most of which were
sold through Tiffany & Co., New York, or
Doll & Richards, Boston. More than half of
the bronzes in this scale are now in American
public collections, among which are The Art
Institute of Chicago, Illinois, The Brooklyn
Museum, New York, the Cincinnati Art
Museum, Ohio, the Cleveland Museum of
Art, Ohio, the Corcoran Gallery of Art,
Washington, D.C., the Detroit Institute of
Arts, Michigan, the University of Miami
Library, Florida, the R.W. Norton Gallery,
Shreveport, Louisiana, Museum of Art,
Rhode Island School of Design, Providence,
the Saint-Gaudens National Historic Site,
Cornish, New Hampshire, and The Saint
Louis Art Museum, Missouri. In 1918, some
years after the sculptor's death, a gilt bronze
example in the large size was made for The
Metropolitan Museum of Art, New York.

The mahogany tabernacle frame on this
work is a contemporary replica of the original
frame, attributed to Stanford White, on the
version of the subject in The Art Institute of
Chicago.

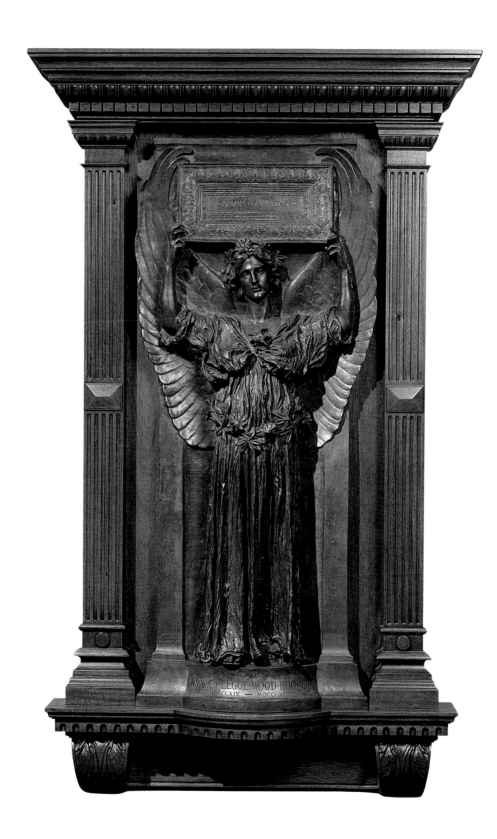

AUGUSTUS SAINT-GAUDENS
(1848-1907)

17. Cornish Celebration Presentation Plaque

Bronze relief, dark brown patina, 32½ x 19½ in.

Signed and inscribed (across the bottom): IN·
AFFECTIONATE·REMEMBRANCE·OF·THE·
CELEBRATION·OF·JUNE·XXIIIMC·MV·/·
AUGUSTA·AND AUGUSTUS·SAINT-GAUDENS·;
also inscribed with the names of each of the
participants in the "A Masque of Ours: The
Gods and the Golden Bowl"

Founder's stamp (on edge, at proper left):
[Gorham foundry cipher]

Model executed in 1905-06

RECORDED: *cf.* John H. Dryfhout, *The Work
of Augustus Saint-Gaudens* (1982), pp. 276-77
no. 202 illus.

During the summer of 1905 the residents of
Cornish, New Hampshire, mounted a theat-
rical production called "A Masque of Ours:
The Gods and the Golden Bowl" to cele-
brate the twentieth anniversary of Augustus
and his wife Augusta Saint-Gaudens' found-
ing of the art colony in that town. Among the
participants in the production were Maxfield
Parrish, Kenyon Cox, Herbert Adams,
Charles Platt, Everett Shinn, and other
painters, sculptors, writers, architects, and
their families. To commemorate the event,
Saint-Gaudens created this relief, which
served as the model for the reduced replicas
(silvered bronze, 3⅛ x 1¾ in., cast by Tiffany
& Co., New York) that the sculptor pre-
sented the following summer to each of the
ninety participants in the production.

Another example of this bronze model is in
the collection of the Saint-Gaudens National
Historic Site, Cornish, New Hampshire.

The bronze is accompanied by one of the
silvered bronze plaquettes.

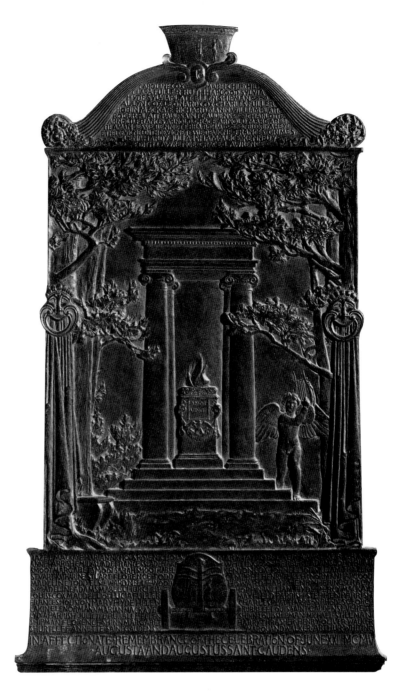

DANIEL CHESTER FRENCH
(1850-1931)

18. Wisdom

Plaster, 58 in. high

Executed between 1898 and 1900

RECORDED: *cf.* Julie C. Gauthier, *The Minnesota Capitol Official Guide and History* (1907, revised ed. 1939), p. 14: "[Wisdom] is perhaps the most beautiful of the six statues in its poise and its expression of severity tempered with kindliness." // *cf.* Neil B. Thompson, *Minnesota's State Capitol: The Art and Politics of a Public Building* (1974), pp. 37-38 // *cf.* Rena Neumann Coen, *Painting and Sculpture in Minnesota, 1820-1914* (1976), p. 94

EXHIBITED: Hirschl & Adler Galleries, New York, 1985, *The Arts of the American Renaissance*, pp. 40-41 no. 21 illus. in color

EX COLL.: Saint Paul Institute of Arts and Sciences, Minnesota, until about 1968-69; to the Minnesota Museum of Art, Saint Paul, until about 1975-76; to private collection, Saint Paul, until 1982

In 1898 Daniel Chester French was commissioned by the prominent architect Cass Gilbert (1859-1931) to create sculptures for the facade of Gilbert's new Minnesota State Capitol Building in Saint Paul, an undisputed masterpiece of the American Renaissance. French's sculptural program included six allegorical figures representing the civic and personal virtues of *Truth*, *Bounty*, *Wisdom*, *Prudence*, *Integrity*, and *Courage*, to be placed above the second-story arcade, and beneath his gilded quadriga, or chariot group, entitled *Progress of the State*.

French prepared the working models for the six allegorical figures in his New York studio and completed them in 1900. The plasters, this *Wisdom* among them, were then sent off to Purdy and Hutcheson, Saint Paul stone carvers, to be enlarged in marble to approximately twice their size for the Capitol Building facade, where *Wisdom* would be installed first from the left.

In addition to *Wisdom*, only French's plaster model for *Truth* (collection of The Art Institute of Chicago, Illinois) is known to have survived.

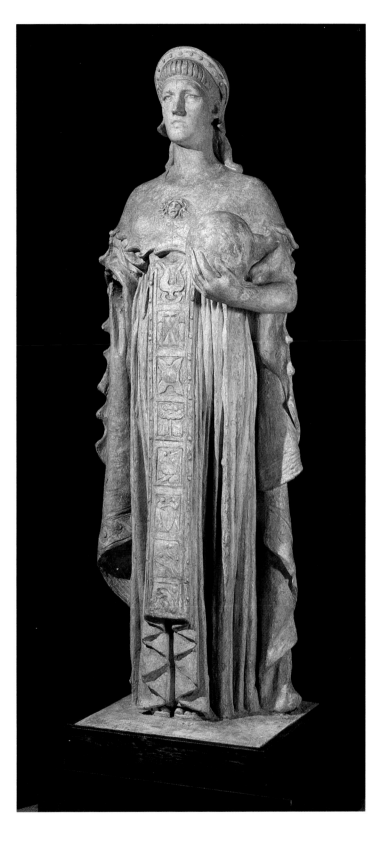

DANIEL CHESTER FRENCH
(1850-1931)

19. Spirit of Life

Bronze, dark brown patina with traces of verdigris, 49¼ in. high

Signed and dated (on the base): D.C. French/May 1914

Founder's mark (on the base): ROMAN BRONZE WORKS N.Y.

RECORDED: *cf.* Michael Richman, *Daniel Chester French: An American Sculptor* (1976), pp. 133-34, 136 no. 9 illus., 137-38, 140 no. 9 // Michael Forest, *Art Bronzes* (1988), pp. 262 no. 5.17, 276 illus. in color

EXHIBITED: Hirschl & Adler Galleries, New York, 1985, *The Arts of the American Renaissance*, pp. 2 illus. in color as frontispiece, 44-45 no. 23 illus. in color // Hirschl & Adler Galleries, New York, 1986, *From the Studio: Selections of American Sculpture 1811-1941*, pp. 48-49 no. 31 illus. in color

Four years after the death of the prominent New York businessman Spencer Trask (1844-1909), Daniel Chester French was commissioned to create a memorial to him at Saratoga Springs, New York, Trask's longtime summer residence. French worked on the project in collaboration with the architect Henry Bacon (1866-1924). An architectural fountain setting, with a central allegorical figure, was devised, and French began to work up small maquettes in 1913 for what ultimately would become the central *Spirit of Life* figure in the *Spencer Trask Memorial*. He completed this working model in 1914, and in the subsequent year used it as the basis for the full-scale model, which was cast into bronze and installed in Congress Park, Saratoga Springs, in 1915.

Eight bronzes of this working model were made. Others are in the collections of the Indianapolis Museum of Art, Indiana (cast in 1915), Chesterwood, French's former summer home and studio, Stockbridge, Massachusetts (cast in 1922), The Newark Museum, New Jersey, The Chrysler Museum, Norfolk, Virginia, the Wilson Library, University of North Carolina, Chapel Hill, and a library in New England. One of the bronzes is unlocated.

According to Michael Richman, Editor of The Daniel Chester French Papers, two of the eight bronzes of the *Spirit of Life* were cast by Roman Bronze Works, New York, as recorded in French's account books. One of these was delivered to the sculptor in July 1924 and the other, in September 1926.

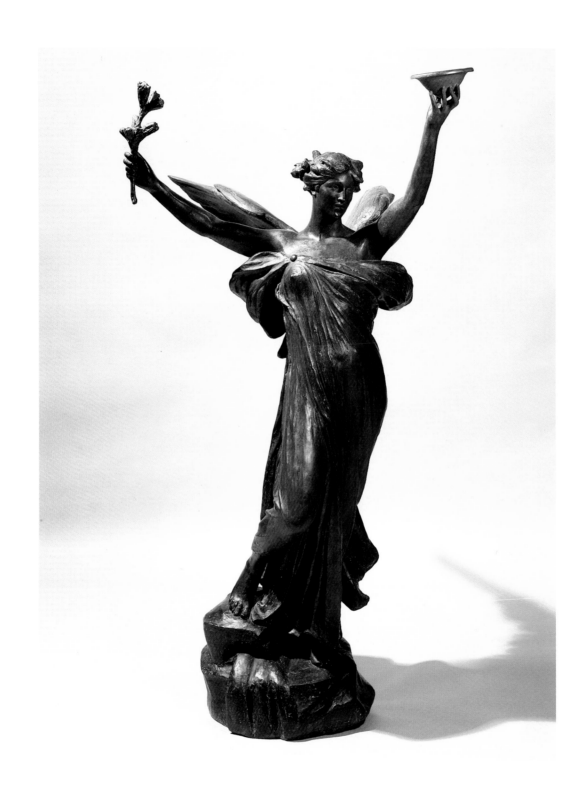

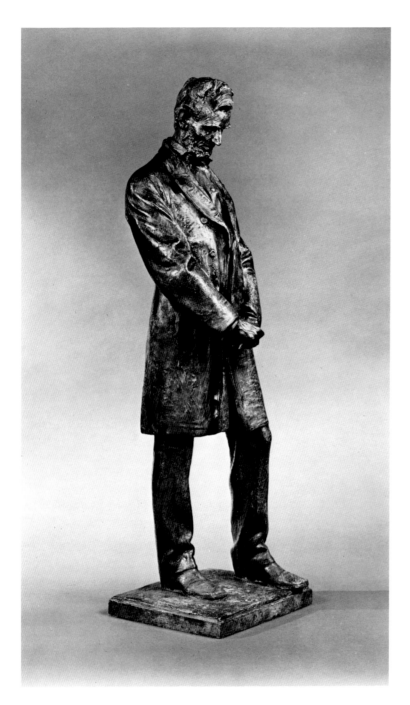

DANIEL CHESTER FRENCH
(1850-1931)

20. Abraham Lincoln

Plaster, shellacked, 38¾ in. high

Signed, dated, and inscribed (on the base): Daniel C French Sc/1912

RECORDED: *cf.* Michael Richman, *Daniel Chester French: An American Sculptor* (1976), pp. 123, 124 no. 5 plaster illus., 126-27, 128 no. 10 bronze illus., 129 no. 10

EX COLL.: the sculptor; to the estate of the sculptor, and Roman Bronze Works, New York, until 1988

In 1909, on the one-hundredth anniversary of Abraham Lincoln's birth, Daniel Chester French was commissioned by the Lincoln Centennial Memorial Association of Nebraska to create a monument to the six-teenth President of the United States for the capital city of Lincoln. He engaged the archi-tect Henry Bacon (1866-1924) to design the pedestal and architectural setting for his pro-posed nine-foot monument. French com-pleted this working model in January 1911; it was unanimously approved by the commis-sioning board and was then used by the sculptor as the basis for the full-scale statue. The Memorial Association ran out of funds towards the end of the project, and it was agreed that in lieu of final payment the sculp-tor would be allowed to have bronzes cast from the original working model. Twelve or more bronzes were made in the years after the monument was officially dedicated in 1912.

This is an original plaster of the working model. Bronzes of the subject are in The Art Institute of Chicago, Illinois, the Fogg Art Museum, Cambridge, Massachusetts, the Whitney Museum of American Art, New York, The Newark Museum, New Jersey, the University of Nebraska Art Galleries, Lincoln, The Union League, Philadelphia, Pennsylvania, the Stockbridge Plain School, Massachusetts, Ball State Art Gallery, Mun-cie, Indiana, the Wadsworth Atheneum, Hartford, Connecticut, Chesterwood, Stockbridge, Massachusetts, and a private collection, New York.

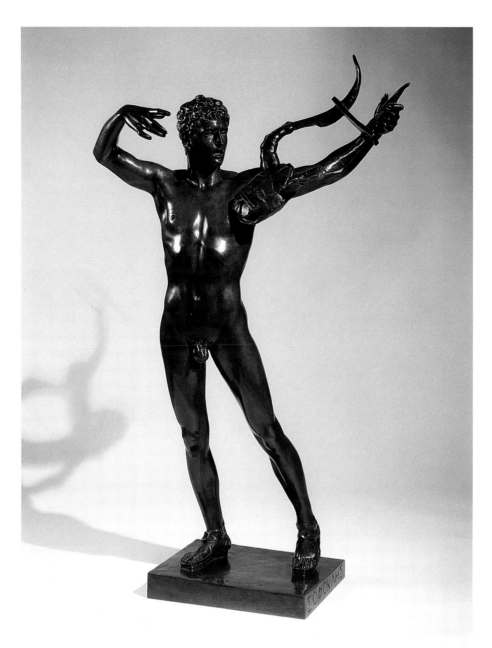

JOHN TALBOTT DONOGHUE
(1853-1903)

21. The Young Sophocles

Bronze, dark brown patina, 44½ in. high

Signed and inscribed (on the base): J
DONOGHVE Sc.

Inscribed in Greek (on the base): SOPHO-
CLES SALAMIS

Founder's mark (on the base): F.
BARBEDIENNE. Fondeur. Paris.

Model executed in 1885

RECORDED: *cf.* Lorado Taft, *The History of
American Sculpture* (1903, reprint 1969),
pp. 432, 434 fig. 71 // *cf.* Albert TenEyck
Gardner, *American Sculpture: A Catalogue of the
Collection of The Metropolitan Museum of Art*
(1965), pp. 60-61 illus. // *cf.* The Newark
Museum, New Jersey, *American Bronze
Sculpture* (1984, text by Gary Reynolds), p. 19
illus.

EXHIBITED: Hirschl & Adler Galleries, New
York, 1988, *Adventure & Inspiration: American
Artists in Other Lands*, p. 106 no. 67 illus. in
color

Having won a scholarship from the Chicago
Academy of Design in his native city of Chi-
cago, Illinois, Donoghue studied in Paris
from 1875 to 1881 at the Ecole des Beaux-
Arts, under François Jouffroy and Jean Alex-
andre Falguière. From 1884 to 1887 the
sculptor lived and worked in Rome, where
he was to return frequently in his later years.

The Young Sophocles, modeled during
Donoghue's years in Rome, was first exhib-
ited in heroic scale (92½ in. high) at the 1886
Paris Salon, where it won an honorable men-
tion. It was later exhibited at the World's
Columbian Exposition, Chicago, in 1893,
where it was awarded first prize. Another
small bronze of the subject is in a private
collection, Pennsylvania; large bronzes are in
the collections of The Art Institute of Chi-
cago, Illinois, and The Metropolitan
Museum of Art, New York.

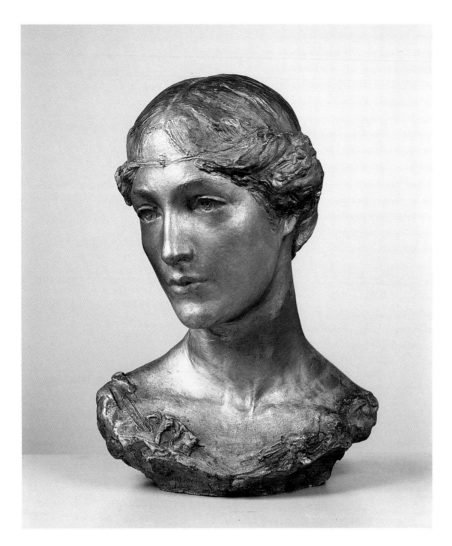

HERBERT ADAMS (1858-1945)

22. Meditation

Gilt plaster, 13 in. high

Signed and dated (at bottom): HERBERT
ADAMS '05

RECORDED: *cf.* John E.D. Trask and J.
Nilsen Laurvik, eds., *Catalogue De Luxe of the
Department of Fine Arts, Panama-Pacific Inter-
national Exposition*, II (n.d., about 1915), p.
430 no. 4210

EX COLL.: family of the sculptor, until 1986

Like many of his fellow artists, Herbert
Adams, a sculptor closely associated with the
American Renaissance movement, studied
at the Ecole des Beaux-Arts, Paris, from 1885
to 1890. There he learned the modeling tech-
niques of contemporary French sculptors,
while sharing with them an interest in Italian
quattrocento art. Adams' idealized busts of
women are considered to be some of his

finest works, and were well recognized as
such during his lifetime. Inspired in part by
the work of the fifteenth-century Florentine
sculptor Francesco Laurana, these busts
often were executed in tinted marble, some-
times in combination with other materials, as
shown in *Primavera*, 1890-93 (Corcoran Gal-
lery of Art, Washington, D.C.) and *La
Jeunesse*, 1894-1910 (The Metropolitan
Museum of Art, New York), or in a variety of
other media, including the gilt plaster used
in this *Meditation*, which also displays subtle
suggestions of polychromy in the subject's
hair and lips.

According to Joel Rosenkranz, who is cur-
rently co-authoring a book on American
sculpture, Adams exhibited an enameled
bronze version of *Meditation* at the 1915 Pan-
ama-Pacific International Exposition, San
Francisco, California, which, along with
three other works, won him a medal.

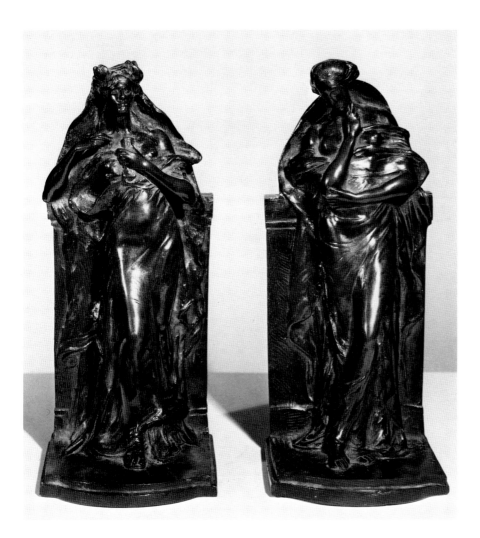

ISADORE KONTI (1862-1938)

23. Poetry and Thought: A Pair of Bookends

Each, bronze, dark brown patina, 10¼ in. high

Each, signed, dated, and inscribed (on the base): © 1914 I. Konti

Models executed in 1911

RECORDED: *cf.* The Hudson River Museum, Yonkers, New York, *The Sculpture of Isadore Konti, 1862-1938* (1974), [n.p.] nos. 39a and 39b illus.

Born in Vienna, Austria, to Hungarian parents, Isadore Konti established himself as a sculptor before emigrating to the United States in 1892. He had studied sculpture at the Imperial Academy in Vienna, but a two-year scholarship in Rome, from 1886 to 1888, proved most influential, for, in Italy, he was able to study firsthand the sculptures of the Italian Renaissance and Baroque periods.

As with other artists of the American Renaissance, allegory played an important role in Konti's imagery, manifesting itself not only in his monumental sculptures for the American world's fairs of 1893, 1901, 1904, and 1915, but also in his smaller-scale pieces. In 1911 Konti produced several pairs of bronze bookends depicting allegorical subjects, including this pair and others symbolizing "Literature," "Drama," and "Reverence Before Knowledge." These works proved quite popular and were sold through a number of galleries, including Gorham and Theodore B. Starr, New York, and Doll & Richards, Boston, Massachusetts.

GEORGE THOMAS BREWSTER
(1862-1943)

24. Portrait of Augustus Saint-Gaudens

Bronze relief, golden brown patina,
15¼ x 12½ in.

Signed, dated, and inscribed (at lower right):
Sketch/from life/Geo T Brewster/1904

Inscribed and dated (at upper left):
AUGUSTUS/SAINT/GAUDENS/MDCCCCIV

Founder's stamp (at lower right): GORHAM
CO

RECORDED: *cf.* National Portrait Gallery,
Washington, D.C., *Permanent Collection:
Illustrated Checklist* (1979), p. 162 illus. // *cf.*
John H. Dryfhout, *The Work of Augustus Saint-
Gaudens* (1982), p. 21 no. C45 illus.

EX COLL.: Stanford White (1853-1906),
Long Island, New York; by descent in the
White family, until about 1970; to private
collection, until 1987

Modeled from life, this work is a tribute to
Augustus Saint-Gaudens (1848-1907), who
had revived in America more than twenty-
five years earlier the Italian Renaissance art
of bas relief. It is executed in low relief,
much in the manner in which Saint-Gaudens
himself worked, and presumably was mod-
eled at Cornish, New Hampshire, where by
this time Saint-Gaudens was living perma-
nently due to his failing health.

Born in Kingston, Massachusetts, George
Thomas Brewster studied at the Massachu-
setts Normal School of Art and, later, at the
Ecole des Beaux-Arts, Paris, under
Augustin-Alexandre Dumont and Marius-
Jean-Antonin Mercié. He was an instructor
at the Rhode Island School of Design, Pro-
vidence, in 1892-93, became a member of
the National Sculpture Society in 1898, and
taught at Cooper Union, New York, from
1900 on.

Other examples of this bronze are in the
collections of the National Portrait Gallery,
Washington, D.C., and the Saint-Gaudens
National Historic Site, Cornish, New
Hampshire.

This work retains its original gilded oak
frame, almost certainly designed by the
architect Stanford White, who also designed
many frames for reliefs by Saint-Gaudens.

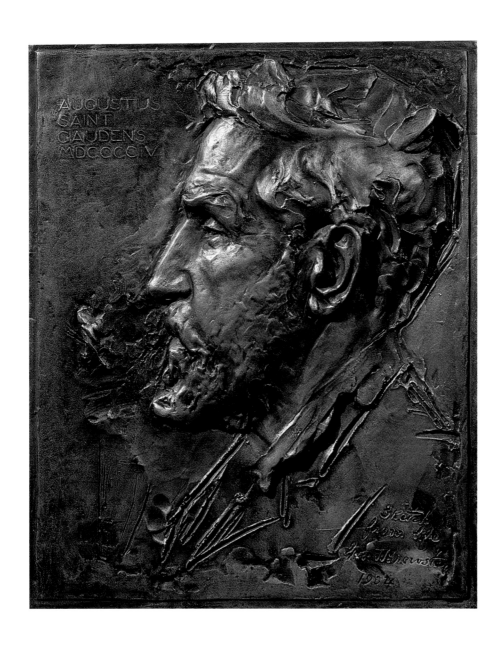

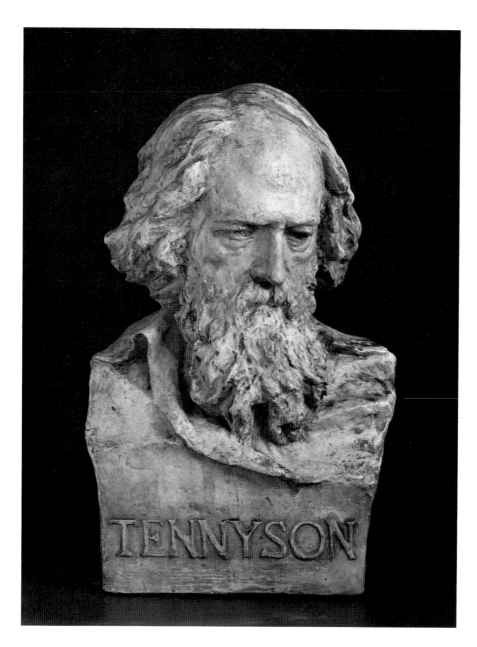

WILLIAM ORDWAY PARTRIDGE
(1861-1930)

25. Bust of Alfred, Lord Tennyson

Plaster, shellacked, 20¾ in. high

Signed and inscribed (on the base): W Ordway Partridge/Sc

Inscribed (on the base): Roman Bronze Works/NY

Model executed in 1899

RECORDED: *cf.* Marjorie Pingel Balge, "William Ordway Partridge (1861-1930): American Art Critic and Sculptor" (Ph.D. dissertation, 1982, University of Delaware, Newark; University Microfilms, 1982), pp. 87, 88 fig. 6, 89 fig. 7, 120, 154, 333 illus., 334

Beginning around 1892 Partridge modeled a series of portraits of British and American writers and poets, which included likenesses of Walt Whitman, John Keats, Thomas Carlyle, Percy Bysshe Shelley, Alfred, Lord Tennyson, and others. In these works, which rank among the sculptor's best, the faces are strongly modeled, while the clothing and hair are left fairly impressionistic. According to Marjorie Balge [*op. cit.*, p. 333], this *Bust of Alfred, Lord Tennyson*, the English poet, was probably modeled from life, as Partridge frequently traveled to London.

Several other versions of the subject in various media are known. Bronzes are in the collections of the National Museum of American Art, Washington, D.C., Bowdoin College Museum of Art, Brunswick, Maine, and the Ponce Museum, San Juan, Puerto Rico. A marble is in the Lyceum Theatre, London, and other plasters are in The Brooklyn Museum, New York, and the Memorial Art Gallery, Rochester, New York.

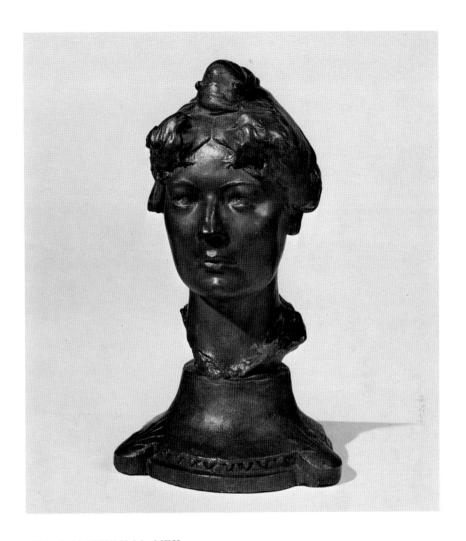

HERMON ATKINS MacNEIL
(1866-1947)

26. Portrait of Carol Brooks MacNeil

Plaster, patinated with bronze powder,
14¼ in. high

Signed (on the base): H A M[ac]Neil

Executed about 1895-1900

EX COLL.: By descent in the sculptor's family to his niece, until about 1985; to [Conner-Rosenkranz, New York, until 1987]

This is a portrait of the sculptor's wife, Carol Brooks MacNeil (1871-1944), a former student of MacNeil's and a sculptor in her own right. The two were married in 1895, and soon thereafter they left for a four-year stay in Rome, where MacNeil had won the distinguished Rinehart Scholarship for study at the American Academy. This portrait was probably executed during their years in Rome.

FREDERICK WILLIAM MacMONNIES
(1863-1937)

27. Bacchante with Infant Faun

Bronze, greenish-black patina (repatinated), 67¼ in. high

Signed and dated (on the base): F MacMonnies 1894

Founder's mark (on the base): JABOEUF & ROUARD. Fondeurs

Model executed between 1893 and 1894

RECORDED: Hildegard Cummings, "Chasing a Bronze Bacchante," in The William Benton Museum of Art, The University of Connecticut, Storrs, *Bulletin* (1984), pp. 12, 14

ON DEPOSIT: Santa Barbara Museum of Art, California, 1986-88

EX COLL.: (by tradition) Julia Marlowe [Southern]; The Music Academy of the West, Santa Barbara, California, until about 1986; to a non-profit foundation, California, until 1989

One of the great public scandals at the end of the nineteenth century was the installation of Frederick MacMonnies' full-size *Bacchante with Infant Faun* (bronze, 83 in. high) in the courtyard of the newly-completed Boston Public Library, Massachusetts. It was the sculptor's first major effort after his great success at the 1893 World's Columbian Exposition, Chicago, Illinois, with the enormous *Barge of State*, and was a gift from the Library's architect, Charles McKim, of the New York firm of McKim, Mead, and White.

The *Bacchante* was in place for only three months in 1896 when the Art Commission of the City of Boston voted to reject it. According to Frederick O. Prince, a Library Trustee and the only vote accepting it, the Commission was concerned with erecting a "monument to inebriety" in conservative Boston [Cummings, *op. cit.*, p. 3]. McKim withdrew his offer and presented the piece in 1897 to The Metropolitan Museum of Art, New York, where it is today. Two additional full-size bronzes are known (Town Hall, Selestat, France, formerly in the Luxembourg Museum, Paris, and the Museum of Fine Arts, Boston, Massachusetts), as well as two full-scale marble replicas (The Brooklyn Museum, New York, and the William Randolph Hearst Collection, San Simeon, California).

In a letter dated January 7, 1931, to Max Farrand at the Henry E. Huntington Library and Art Gallery, San Marino, California, MacMonnies recalled that three bronzes of the subject in this three-quarter scale (approx. 68 in. high) had been cast [quoted in *ibid.*, pp. 12-14]:

> The "Bacchante" on the Huntington grounds is a smaller version of the original in the Metropolitan Museum, and was made in that scale for small gardens or courtyards, in fact, for just such a place as it occupies at San Marino . . . Of the San Marino size, Mrs. Southern, formerly Julia Marlowe, owns one and one other, of which I have lost track, exists somewhere.

Despite MacMonnies' recollections, however, four bronzes of the *Bacchante* in this scale are now known. In addition to this bronze, which almost certainly is the one once owned by the Shakespearian actress Julia Marlowe [Southern] (1865-1950), one remains at the Huntington Library, another is in the collection of the Norton Gallery and School of Art, West Palm Beach, Florida, and a fourth was discovered in recent years in Paris and was published in Hirschl & Adler's 1985 exhibition catalogue titled *The Arts of the American Renaissance* (pp. 74-75 no. 49 illus. in color).

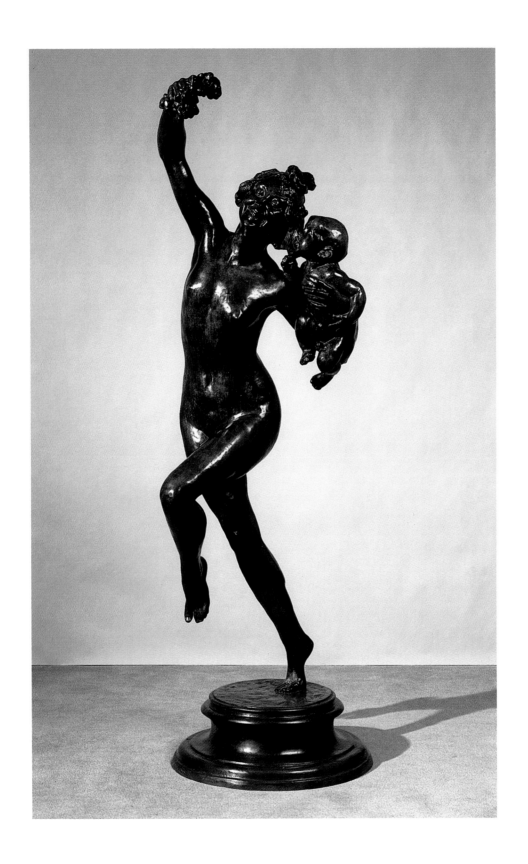

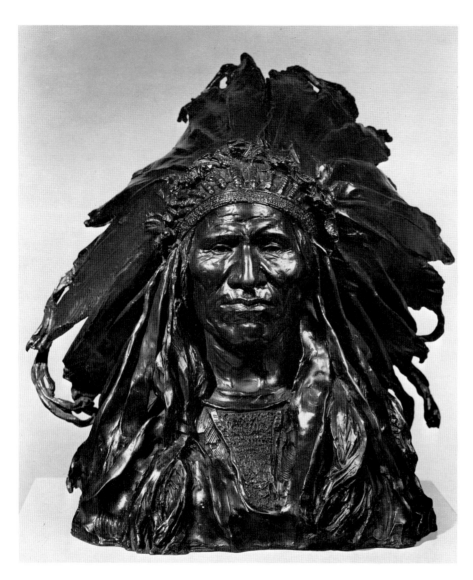

ADOLPH ALEXANDER WEINMAN
(1870-1952)

28. Chief Blackbird, Ogalalla Sioux

Bronze, dark brown patina, 16 in. high

Signed and inscribed (at bottom, proper left): CHIEF/BLACK/BIRD/OGALALLA/SIOUX/ A.A.WEINMAN

Founder's mark (at bottom, proper right): ROMAN BRONZE WORKS/N-Y-

Model executed about 1904

RECORDED: *cf.* Patricia Janis Broder, *Bronzes of the American West* (1974), pp. 192-199 pl. 201 in color // *cf.* The Brooklyn Museum, New York, *The American Renaissance 1876-1917* (1979), p. 228 no. 270 illus.

This work is adapted from one of the figures in Weinman's monument titled *The Destiny of the Red Man*, which he created for the 1904 Louisiana Purchase Exposition in Saint Louis, Missouri, and which first brought him international recognition. There are two versions of *Chief Blackbird*, this type, and another with a North American Indian frieze around the base.

Other examples of this type are in the collections of The Brooklyn Museum, New York, and the Thomas Gilcrease Institute of American History and Art, Tulsa, Oklahoma.

ADOLPH ALEXANDER WEINMAN
(1870-1952)

29a. Rising Day

Bronze, brownish-green patina, 57½ in. high

Signed and inscribed (on the base): A A WEIN-MAN. FECIT.

Founder's mark (on the base): ROMAN BRONZE WORKS N. Y.

Model executed about 1914

RECORDED: *cf.* Juliet James, *Sculpture of the Exposition Palaces and Courts* (1915), pp. 18-19 illus. // *cf.* The National Sculpture Society, New York, *American Sculptor Series: Adolph A. Weinman* (1950), pp. 18 illus., 19 *Fountain of "The Rising Sun"* illus. // *cf.* Whitney Museum of American Art, New York, *200 Years of American Sculpture* (1976), pp. 115 fig. 152, 349 no. 320 // *cf.* The Brooklyn Museum, New York, *The American Renaissance 1876-1917* (1979), p. 228 no. 271 illus.

EX COLL.: Noel T. Arnold, until 1957; by gift to St. Luke's Hospital, San Francisco, California, until 1986

29b. Descending Night

Bronze, brownish-green patina, 55¾ in. high

Signed, dated, and inscribed (on the base): © /A.A..WEINMAN.FECIT.MCMXIV. [1914]

Founder's mark (on the base): CAST BY ROMAN BRONZE WORKS N-Y-

RECORDED: *cf.* Juliet James, *Sculpture of the Exposition Palaces and Courts* (1915), pp. 20-21 illus. // *cf.* The National Sculpture Society, New York, *American Sculptor Series: Adolph A. Weinman* (1950), pp. 16 illus., 17 *Fountain of "The Setting Sun"* illus. // *cf.* Whitney Museum of American Art, New York, *200 Years of American Sculpture* (1976), pp. 115 fig. 151, 349 no. 319 // *cf.* The Brooklyn Museum, New York, *The American Renaissance 1876-1917* (1979), p. 228 no. 272 illus.

EXHIBITED: Hirschl & Adler Galleries, New York, 1986, *From the Studio: Selections of American Sculpture 1811-1941*, pp. 56-57 no. 35 illus. in color

To celebrate the opening of the Panama Canal—and the joining of the Atlantic and Pacific Oceans—one of the great American world's fairs was organized in 1915 in San Francisco, California. Like its predecessors in Chicago, Illinois, in 1893, Buffalo, New York, in 1901, and Saint Louis, Missouri, in 1904, the Panama-Pacific International Exposition brought together painters, sculptors, and architects in a large-scale collaborative effort.

One of the major outdoor decorations at the San Francisco exposition was Adolph A. Weinman's monumental pair of fountain figures entitled *The Rising Day* (or *The Rising Sun*) and *Descending Night* (or *The Setting Sun*). Surmounting enormous decorated columns, the pair, made of plaster reinforced with hay or burlap fibre, was installed in the Court of the Universe, designed by the New York architectural firm of McKim, Mead, and White. The building and its courtyard, known as the "meeting place of the hemispheres," was 700 feet long and 900 feet wide and stood at the northern end of the fairgrounds, between the Palace of Agriculture and the Palace of Transportation.

This pair of bronzes, cast from the sculptor's working models for the monumental plaster figures (destroyed), is one of only four known sets in this large size. The others are in the collections of the Corcoran Gallery of Art and the National Museum of American Art, both in Washington, D.C., and the Krannert Art Museum, University of Illinois, Urbana-Champaign.

Illustrated on the following pages

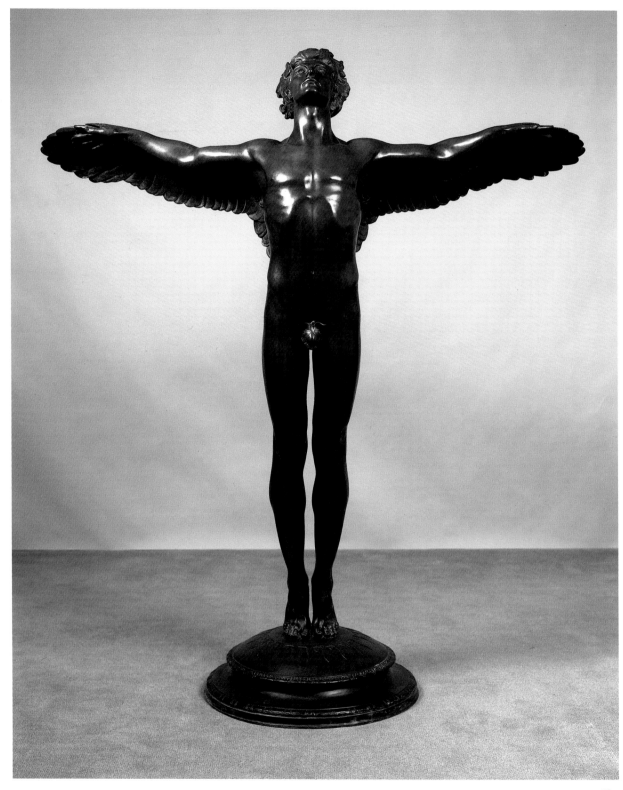

29a

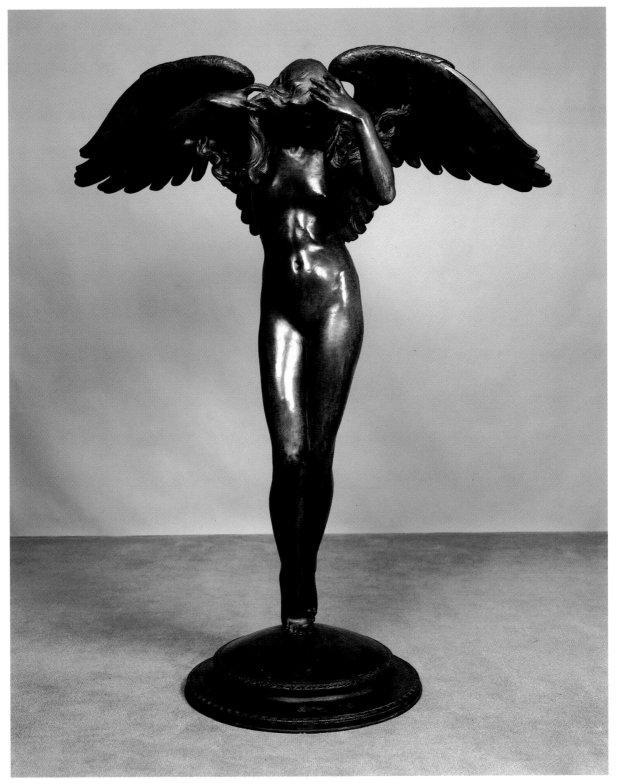

29b

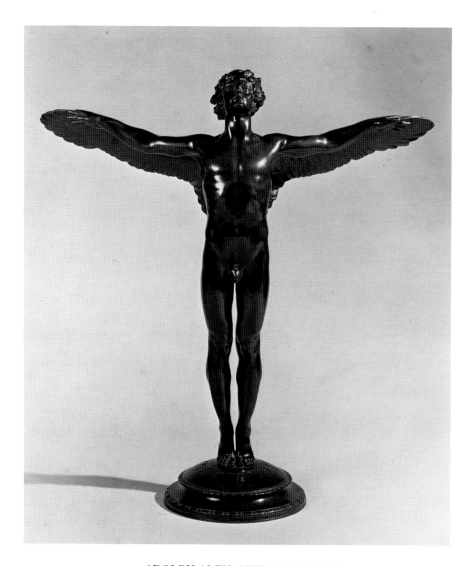

ADOLPH ALEXANDER WEINMAN
(1870-1952)

30a. Rising Day

Bronze, dark brown patina, 26½ in. high

Signed and inscribed (on the base): © /
A.A.WEINMAN.FECIT.

Founder's mark (on the base): CELLINI
BRONZE WORKS N.Y.

Model executed about 1914-15

30b. Descending Night

Bronze, dark brown patina, 25¾ in. high

Signed and inscribed (on the base): © /
A.A.WEINMAN.FECIT.

FOUNDER'S MARK (ON THE BASE): CELLINI
BRONZE WORKS N.Y.

Model executed about 1914-15

These bronzes are reductions of Weinman's
working models (cat. nos. 29a and 29b) for
the monumental fountain figures which he
created for the 1915 Panama-Pacific Interna-
tional Exposition, San Francisco, California.

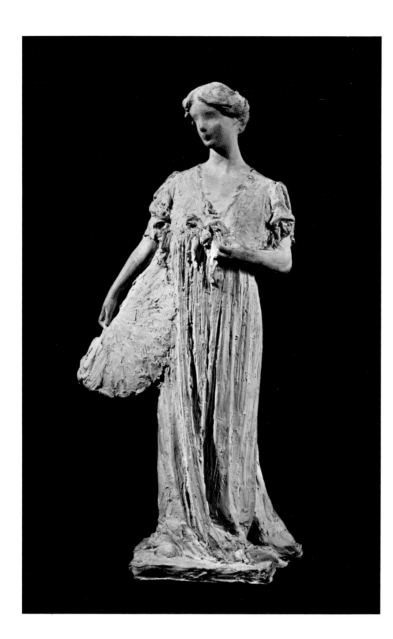

BESSIE POTTER VONNOH (1872-1955)

31. The Fan

Buff-colored terra cotta (bisque), 11⅜ in. high

Executed about 1895-98

RECORDED: *cf.* Lucy Monroe, "Bessie Potter," in *Brush and Pencil*, II (Apr. to Sept. 1898), p. 33

EXHIBITED: Hirschl & Adler Galleries, New York, 1982, *Carved and Modeled: American Sculpture 1810-1940*, p. 81 no. 48 illus., medium given as plaster [*sic*], title given as *Standing Woman with Fan* // Hirschl & Adler Galleries, New York, 1985, *The Arts of the American Renaissance*, p. 117 no. 81 illus., medium given as plaster [*sic*], date given as about 1905-10

EX COLL.: [Hirschl & Adler Galleries, New York, 1980-85]; to private collection, New York, 1985-87

A terra cotta of *The Fan*, which is quite possibly the same as this example, appears first to have been exhibited in 1910 at The Corcoran Gallery of Art, Washington, D.C., and subsequently at McLees Gallery, Philadelphia, in 1911, and the Pennsylvania Academy of the Fine Arts, Philadelphia, in 1912. The piece, however, had been modeled more than a decade earlier. In an article published in 1898, Lucy Monroe described a work which is, almost certainly, *The Fan* [*loc. cit.*]: "The girl holding a fan . . . has . . . character; her charming personality is vividly presented. One understands what she would do and how she would talk if one grew to know her better."

A silvered bronze casting of this work, the only other version in any medium currently known, is in the collection of the National Museum of Women in the Arts, Washington, D.C.

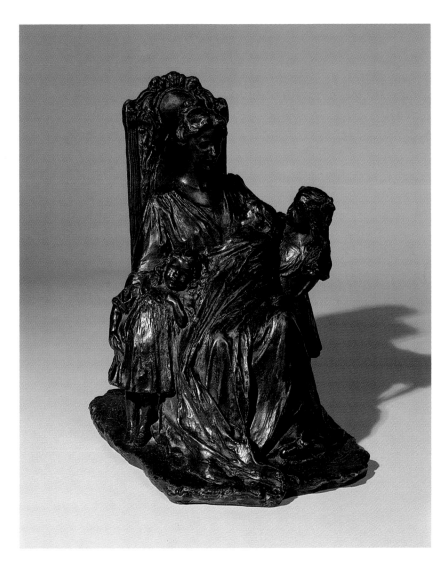

BESSIE POTTER VONNOH (1872-1955)

32. Enthroned

Bronze, dark brown patina, 12 in. high x 7½ in. wide x 10 in. deep

Signed and dated (on the base): Bessie Potter Vonnoh/1902

Inscribed (on the base): Copyright

Numbered (on the base): No. IV

Founder's mark, with casting date (on the base): Roman Bronze Works N.Y. 1905

RECORDED: *cf.* Albert TenEyck Gardner, *American Sculpture: A Catalogue of the Collection of The Metropolitan Museum of Art* (1965), p. 113 // *cf.* Beatrice Gilman Proske, *Brookgreen Gardens Sculpture* (revised ed. 1968), p. 82

Despite the fact that Bessie Potter Vonnoh was trained by Lorado Taft in the monumental tradition of sculpture and assisted him on his sculptures for the 1893 World's Columbian Exposition, Chicago, Illinois, she distinguished herself as an artist by creating small-scale genre groups of mothers and children or dainty young girls in graceful, flowing dresses. These distinctive works were popular among the critics and the collecting public alike, and were well recognized in art competitions, often winning a gold, silver, or bronze medal.

A charming and intimate portrait of motherhood, *Enthroned* was awarded the Julia A. Shaw Memorial Prize by the Society of American Artists, New York, in 1904. According to the sculptor, twenty-one

bronzes of this model were made [Gardner, *loc. cit.*]. Other examples are in the collections of The Metropolitan Museum of Art, New York (no. VI in the series), the Corcoran Gallery of Art, Washington, D.C. (no. XII), and a private collection, California (no. III).

BESSIE POTTER VONNOH (1872-1955)

33. In Arcadia

Bronze, greenish-brown patina, 11⅝ in. high
x 28½ in. wide x 5⅝ in. deep (excluding
original marble base), pipe replaced

Signed and numbered (on the base): Bessie
Potter Vonnoh A5

Founder's mark (on the base): ROMAN
BRONZE WORKS N.Y.

Model executed about 1926

RECORDED: Hirschl & Adler Galleries, New
York, *From the Studio: Selections of American
Sculpture 1811-1941* (1986, text by Susan E.
Menconi), p. 64, as "in a private collection,
New York"

EX COLL.: [Lillian Nassau, Inc., New York];
to private collection, New York, until 1988

In Arcadia appears to have been exhibited
first in 1926-27 at the National Academy of
Design, New York, in the *Winter 1926* annual
show, where it was listed as no. 274. During
the 1920s and 1930s, Vonnoh devoted most of
her time to creating fountain groups such as
Springtime of Life, 1928 (private collection), a
bird fountain, 1913-25 (Ormond Beach Park,
Florida), a bird bath, 1925-27 (Roosevelt Bird
Sanctuary, Oyster Bay, New York), and the
Frances Hodgson Burnett Memorial, 1937 (Cen-
tral Park, New York). Her smaller-scale
works of this period, therefore, are relatively
rare.

Another example of this bronze (no. A3) is in
a private collection, Pennsylvania.

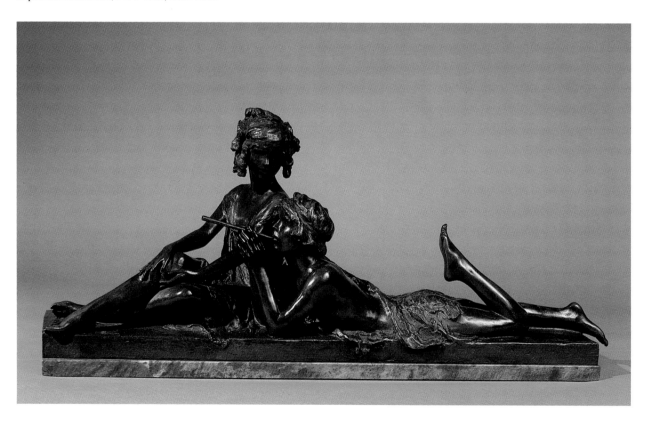

EVELYN BEATRICE LONGMAN
(1874-1954)

34. Victory

Bronze, medium brown patina, 27 in. high
(excluding black base)

Signed and dated (on the ball): EVELYN B.
LONGMAN/1908

Numbered (on the ball): No. 13

Founder's mark (along bottom rim): ROMAN
BRONZE WORKS N.Y.

Model executed in 1904

RECORDED: *cf.* Albert TenEyck Gardner,
*American Sculpture: A Catalogue of the Collection
of The Metropolitan Museum of Art* (1965), pp.
116-17 illus. // *cf.* Beatrice Gilman Proske,
Brookgreen Gardens Sculpture (revised ed.
1968), pp. 134-35 illus., 136

From 1901 until 1904 Evelyn Beatrice Long-
man worked as an assistant in Daniel Chester
French's studio, the only woman ever to
have done so. Her first significant effort as a
sculptor in her own right was the colossal
figure of *Victory* (plaster, now destroyed)
which she created for the dome of Festival
Hall at the 1904 Louisiana Purchase Exposi-
tion, Saint Louis, Missouri. The *Victory*
proved so successful that a decade later,
when she received an important commission
for a sculpture to surmount the American
Telegraph and Telephone Building, New
York, she adapted its composition to create
the gilded male figure of *Electricity* (now
housed in the lobby of the new A.T.& T.
Building, New York).

Reductions of the *Victory* were made in 1908
from the working model for the monumental
version. According to A.T. Gardner [*loc. cit.*],
approximately thirty-five bronzes in this
scale were cast. Other examples may be
found in the collections of The Metropolitan
Museum of Art, New York (No. 1), The
National Academy of Design, New York,
Brookgreen Gardens, Murrells Inlet, South
Carolina, The Indianapolis Museum of Art,
Indiana, The Toledo Art Museum, Ohio,
and The Saint Louis Art Museum, Missouri.
In addition, two larger bronzes of the subject
are known. One, measuring 50 in. high, was
cast from the working model plaster
(destroyed) and is in the collection of The
Art Institute of Chicago, Illinois. The other
of 1905, 58¾ in. high, was a special commis-
sion by several members of the Union
League Club, Chicago, in whose collection it
remains today.

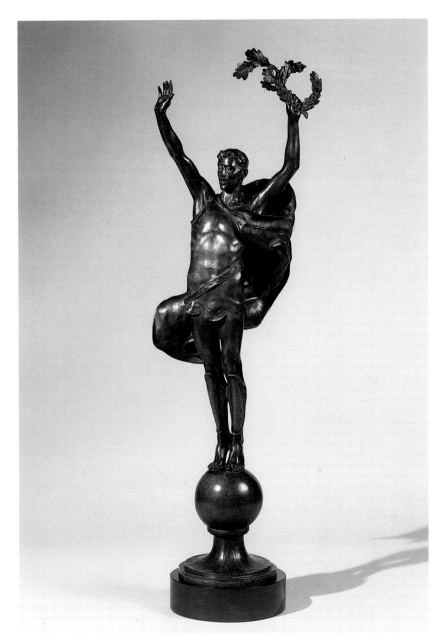

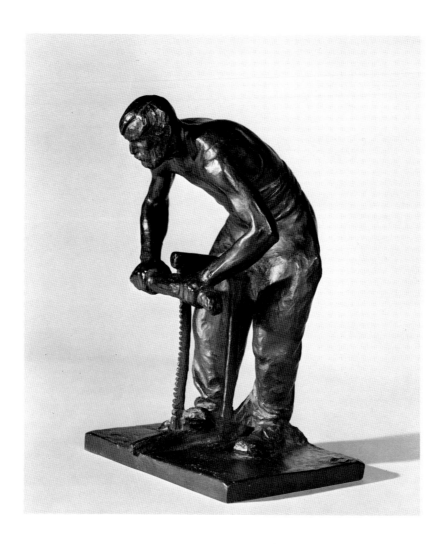

MAHONRI MACKINTOSH YOUNG
(1877-1957)

35. Woodcutter with Bucksaw

Bronze, dark brown patina, 12 in. high

Signed (on top of the base): MAHONRI

Founder's stamp (on top of the base): CIRE/A. VALSUANI/PERDUE

Model executed in 1926

EXHIBITED: Rehn Gallery, New York, 1928, no. 5 or 6, as *Boucheron* // Kraushaar Gallery, New York, 1940, no. 78

EX COLL.: [Kraushaar Gallery, New York]; to private collection

Mahonri Young was born in Salt Lake City, Utah, and was a grandson of Brigham Young, the founder of the Mormon Church. At an early age, Mahonri began modeling birds and animals in clay, and somewhat later took classes in illustration in Salt Lake City. He moved to New York in 1899 and attended the Art Students League, after which he went to Paris for study at the Académie Julian. He devoted himself initially to drawing and painting, but a visit to Italy focussed his attention on sculpture.

His first bronzes, with titles such as *The Shoveler*, *Man Tired*, and, in 1904, *Bovet Arthur—A Laborer*, were early expressions of what was to be one of Young's most significant contributions to American sculpture: his series of working men. Beatrice Gilman Proske in *Brookgreen Gardens Sculpture* (revised ed. 1968), p. 155, wrote about this aspect of his work:

> Unconcerned with sociological implications, the sculptor has centered his attention on the purely sculptural quality of the men whom he observed. ... Without superfluous detail, these figures give at once the essential quality of each man and his occupation. By bringing actuality close to his audience he has made the dignity of labor more apparent than could be done by any number of more emphatic abstractions. It was this phase of his work which won for him a silver medal at the Panama-Pacific Exposition.

Woodcutter with Bucksaw will be included in the forthcoming Daniel Hodgson/Peter H. Davidson Gallery catalogue raisonné of Mahonri Young's work as no. 108. Although the exhibition records at the Rehn and Kraushaar galleries [*loc. cit.*] suggested that at least one bronze of the subject was made, until the recent discovery of this work only the plaster model (collection of Brigham Young University, Salt Lake City, Utah) was known.

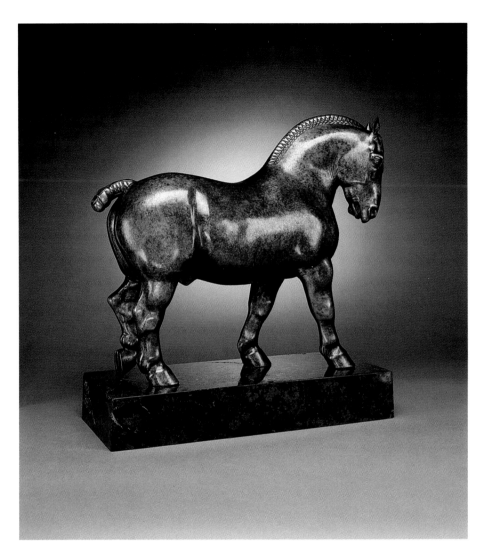

HERBERT HASELTINE (1877-1962)

36. Suffolk Punch Stallion: Sudbourne Premier

Bronze, reddish-gold patina, 10⅞ in. high x 13 in. long x 4½ in. deep (excluding original marble base)

Signed and dated (on marble base): HH [monogram]/1949

Model executed between 1922 and 1925

EXHIBITED: Frank Partridge, London, England, 1953, *Herbert Haseltine: Exhibition of Sculpture*, [n.p.] no. 13, lent by Dr. D. Halley-Smith // Galerie Jansen & Cie., Paris, France, 1955, *Herbert Haseltine: Exposition de Sculptures*, [n.p.] no. 17 illus. in color, lent by Dr. D. Halley-Smith // Graham Gallery, New York, 1987, *The Animal in Sculpture: American and European—19th and 20th Century*, pp. 49 illus. in color, 83 [n.n.] // Hirschl & Adler Galleries, New York, 1988, *Adventure & Inspiration: American Artists in Other Lands*, p. 165 no. 116 illus. in color

EX COLL.: Dr. D. Halley-Smith, about 1949; by descent in the Halley-Smith family, until 1987

Suffolk Punch Stallion: Sudbourne Premier is part of Haseltine's series of twenty "British Champion Animals," which the sculptor modeled in various parts of England, Scotland, and Ireland from 1922 to 1925.

Sudbourne Premier was foaled in 1919 and bred by the Rt. Hon. Lord Manton. In 1923 he was acquired by Percy C. Vestey, Esq., of Easton Park, Wickham Market, Suffolk. His sire was Sudbourne Beau Brocade, and his dam, Sudbourne Moonlight.

According to both the Frank Partridge and Galerie Jansen exhibition catalogues [*loc. cit.*], this bronze is a sand cast and was done by the Alexis-Rudier Foundry, Paris, in 1949; it was patinated by the Valsuani Foundry in Paris. A one-quarter life-size example in bronze, plated with gold and ornamented with lapis lazuli, ivory, and onyx, was purchased in the late 1920s by the French Government for the Luxembourg Museum in Paris. Another ornamented bronze example is in the collection of the Fine Arts Museums of San Francisco, California, and a third, which was acquired in the early 1930s by Marshall Field of Chicago and presented to the Field Museum, together with a burgundy stone carving of the same subject, is now in the collection of the Virginia Museum of Fine Arts, Richmond.

LEE O. LAWRIE (1877-1963)

37. Arts and Industries, a pair of panels

Each, polished bronze with nickle relief, 84 x 21¼ in.

Executed about 1930-31

RECORDED: "Lee Lawrie's Recent Sculpture at Harrisburg," in *Architecture*, LXV (May 1932), p. 286 this pair illus. // "Commonwealth of Pennsylvania: Education Building, Harrisburg, Pennsylvania" (n.d., informational brochure), [n.p.] another pair illus.

EX COLL.: Education Building, Commonwealth of Pennsylvania, Capitol Park, Harrisburg, about 1930-31–until 1972; private collection, Virginia, about 1980–until 1989

Perhaps best known for his enormous bronze figure of *Atlas* and other work at Rockefeller Center, New York, Lee Lawrie was a leading sculptor in America between the First and Second World Wars. Lawrie specialized in architectural sculpture, which was Art Deco in style and often based on Classical Greek or Assyrian imagery. He received many important public and ecclesiastical commissions, including work for the Nebraska State Capitol Building, Lincoln, St. Thomas Church, New York, the Los Angeles Public Library, California, the National Academy of Sciences, Washington, D.C., and others.

This pair of reliefs, depicting various aspects of man's creative endeavors, is one of six sets of elevator doors which Lawrie created around 1930-31 for the Education Building at the Pennsylvania State Capitol, Harrisburg. In order to make each of pair of doors unique, Lawrie rearranged the eight allegorical panels in various configurations. In this pair, the four panels on the left-hand door represent, top to bottom, "Exploration," "Literature," "Architecture," and "Drama." Those on the right-hand door depict "Religion," "Physical Labor," "Sculpture," and "Music." The panel symbolizing "Sculpture" is inscribed, in Greek, with the name "Phidias." Phidias was, of course, the renowned Greek sculptor who created for the Parthenon in Athens the enormous polychromed statue of Athena with her Nike, a miniature replica of which is depicted here.

In 1972, when the Education Building's hand-operated elevators were replaced with automatic ones, Lawrie's panels were removed from the site and replaced with plain bronze doors embossed with the State Seal of Pennsylvania.

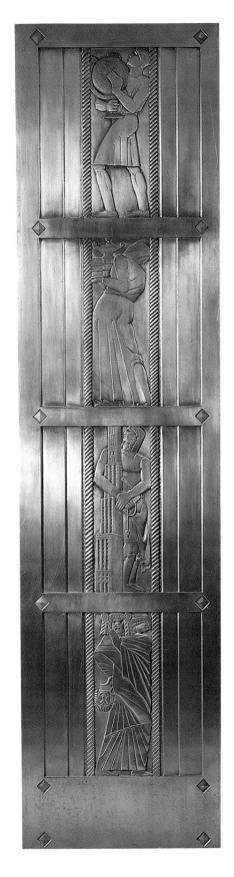
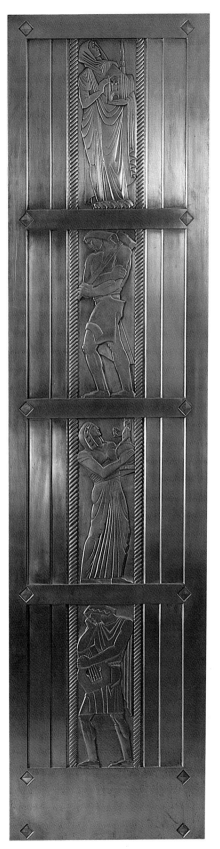

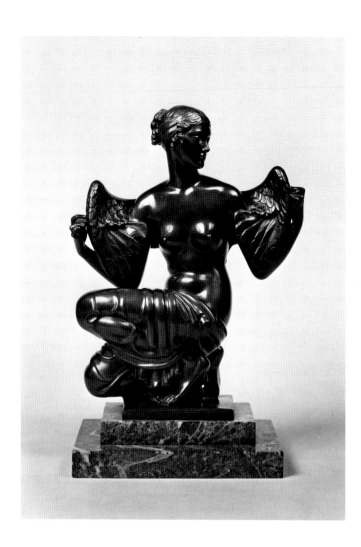

JOHN GREGORY (1879-1958)

38. Philomela

Bronze, dark brown patina, 12 in. high
(excluding original stepped marble base)

Signed, dated, and inscribed (on the base):
John Gregory/1922 ©

Titled (on the base): PHILOMELA

Numbered (on the base): № 18

Founder's mark (on the base); ROMAN
BRONZE WORKS N-Y-

Model executed about 1921

RECORDED: *cf.* Albert TenEyck Gardner,
*American Sculpture: A Catalogue of the Collection
of The Metropolitan Museum of Art* (1965), p.
139 // *cf.* Beatrice Gilman Proske, *Brookgreen
Gardens Sculpture* (revised ed. 1968), p. 303

British by birth, John Gregory came to America at the age of fourteen. In 1900 he became a pupil of J. Massey Rhind, while studying at night for three years at the Art Students League, New York, under George Gray Barnard and Hermon Atkins MacNeil. He then went to Paris for three years of training at the Ecole des Beaux-Arts. Gregory became an American citizen in 1912 and that year left for Rome, where he had won a three-year scholarship for study at the American Academy. Upon his return to the United States, he established himself as a sculptor of architectural ornament and garden figures.

In Greek mythology, Philomela was an Athenian princess who was transformed into a swallow (Roman legend has it as a nightingale) while fleeing her brother-in-law Tereus. She is shown here sporting delicate wings.

The plaster model for *Philomela* was awarded the medal of honor at the Architectural League, New York, in 1921. Although the sculptor had stated [Gardner, *loc. cit.*] that the work was cast in an edition of eleven bronzes, obviously more were made inasmuch as the present bronze is no. 18. Another bronze of the subject is in the collection of The Metropolitan Museum of Art, New York.

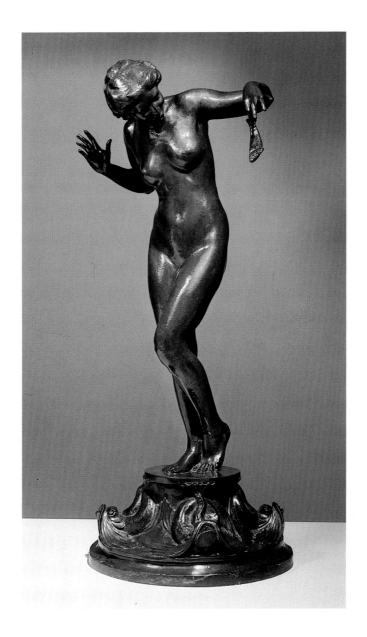

HARRIET WHITNEY FRISHMUTH
(1880-1980)

39. Girl with Fish

Bronze, dark brown patina, 28¾ in. high

Signed, dated, and inscribed (on the base):
HARRIET W FRISHMUTH-COPYRIGHT-1913-

Founder's mark (on the base): GORHAM CO.
FOUNDERS [and impressed with Gorham
Foundry seal]

TO BE RECORDED: Janis Conner and Joel
Rosenkranz, *Rediscoveries in American Sculpture: Studio Works 1893-1939* (1989), illus.

EXHIBITED: Hirschl & Adler Galleries, New
York, 1982, *Carved and Modeled: American
Sculpture 1810-1940*, p. 85 no. 52 illus. in color
// Whitney Museum of American Art, Fairfield County, Stamford, Connecticut, 1984,
*The Feminine Gaze: Women Depicted by Women
1900-1930*, pp. 6 illus., 14 [n.n.] // The Parrish Art Museum, Southampton, New York,
1985, *Fauns and Fountains: American Garden
Sculpture 1890-1930*, [n.p.] no. 4 illus.

EX COLL.: [James Graham and Sons, New
York, 1973-76]

Although the sculptor said that the present
bronze was commissioned as a fountain and
was unique, another casting of it is known in
a private collection, Philadelphia,
Pennsylvania.

The sculpture is piped as a fountain.

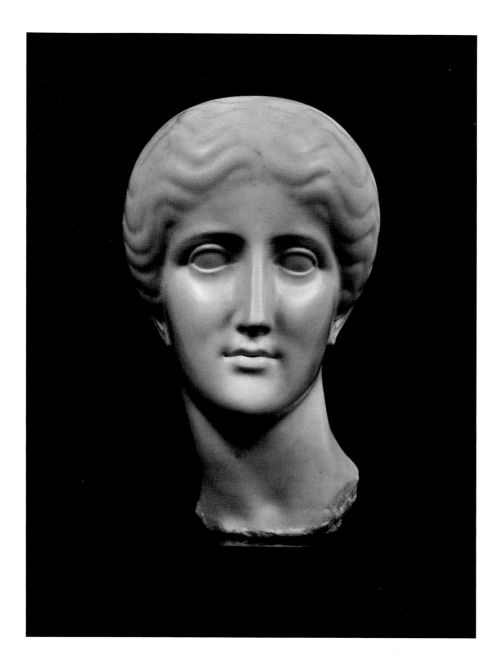

ELIE NADELMAN (1882-1946)

40. Head of a Woman (Classical Head)

Marble, 16 in. high (excluding granite base)

Signed (on edge of neck): ELI NADELMAN

Executed about 1909-10

RECORDED: Helena Rubinstein, *My Life for Beauty* (1966), shown in photo of hallway in her New York apartment // Athena T. Spear, "Elie Nadelman's Early Heads (1905-1911)," in *Allen Memorial Art Museum Bulletin*, XXVIII (Spring 1971), pp. 202 fn. 5, 216, 218 fig. 17 // Athena T. Spear, "Acquisitions of Modern Art by Museums: Early Marble Head by Nadelman at Oberlin," in *Burlington Magazine*, CXIV (July 1972), p. 509 // Lincoln Kirstein, *Elie Nadelman* (1973), p. 290 no. 21, as *Ideal Head*

EXHIBITED: Paterson's Gallery, London, England, 1911

EX COLL.: the sculptor; to [Paterson's Gallery, London, 1911]; to Helena Rubinstein (Princess Gourielli-Tchkonia), New York, and Paris, in 1911; to [sale no. 2431, Parke-Bernet Galleries, New York, April 27, 1966, *The Helena Rubinstein Collection: Modern Paintings and Sculpture, Part Two*, p. 24 lot 613 illus., as *Classical Head*]; to Joseph H. Hirshhorn, New York; to Hirshhorn Museum and Sculpture Garden, Smithsonian Institution, Washington, D.C., until 1988

This idealized marble head is part of a group of related works that Nadelman created from about 1906 on, while living in Paris, and later New York. Their inspiration is recognizable as deriving from the Hellenistic fragments that Nadelman would have seen at the Louvre, although they are not mere copies of antique models. With their highly polished surfaces, decorative, wavy patterns of hair, and abstracted demeanors, these works could have been created only by Nadelman, whose distinctive style emerged during his years in Paris.

The first owner of this work, Helena Rubinstein, the cosmetics magnate, was one of Nadelman's earliest patrons, and certainly his most munificent. In addition to other works, she purchased the entire exhibition of Nadelman sculptures shown at Paterson's Gallery, Bond Street, London, in April 1911, among which were at least ten and possibly as many as fifteen highly polished marble heads, including the present work.

ELIE NADELMAN (1882-1946)

41. Duck

Marble, 11⅜ in. high

Signed (on the base): ELI NADELMAN

Executed about 1920-25

RECORDED: cf. Lincoln Kirstein, *Elie Nadelman* (1973), p. 306 no. 189, dates as "1932-36 (?)" // cf. Cynthia Nadelman, "Elie Nadelman's Beauport Drawings," in *Drawing*, VII (Nov.-Dec. 1985), p. 78

EX COLL.: the sculptor; by gift to Carman Messmore, New York, c. late 1920s–until 1975; by descent in the family, until 1989

Although Lincoln Kirstein stated [*loc. cit.*] that two carvings of this subject exist, at least four marbles are now known. In addition to the present work, two remain in the collection of the sculptor's estate, and one is in a private collection, New York; there is also a bronze in a New York private collection. Drawings relating to the sculpture are in the Santa Barbara Museum of Art, California.

The fact that this work is signed "Eli," rather than "Elie," would suggest that it was executed prior to the sculptor's move to the United States in 1914. In general it is thought that Nadelman changed the spelling of his first name upon his arrival in this country.

However, based upon stylistic grounds and the relationship of the marble to several drawings of cormorants that Nadelman executed during the summer of 1920 in Gloucester, Massachusetts [Nadelman, *op. cit.*, p. 78 fig. 6], a date of 1920-25 seems more likely.

The original owner of this work, Mr. Carman Messmore, was a Vice President at M. Knoedler & Company, New York, from 1921 until his death in 1975. He was given the piece by the sculptor in the late 1920s, probably in 1927, the year that Nadelman had a show at Knoedler's.

ELIE NADELMAN (1882-1946)

42. Standing Buck

Bronze, dark brown patina, 27⅛ in. high (excluding original onyx base)

Signed (on proper left antler): ENADEMAN [*sic*]

Numbered (on proper right antler): N = 2

Model executed about 1915

RECORDED: *cf.* Lincoln Kirstein, *Elie Nadelman* (1973), p. 305 no. 187 // *cf.* Whitney Museum of American Art, New York, *The Sculpture and Drawings of Elie Nadelman* (1975, text by John I.H. Baur), pp. 54 no. 46 illus., 55 no. 46, as *Buck Deer*

EX COLL.: private collection, New York, about 1970-75–until 1988

Standing Buck is one of a small series of elegant animal subjects that Nadelman created during the early to mid-teens, when he was living first in Paris and then New York. These works—comprised principally of two freestanding horses and four deer in various attitudes—are among the sculptor's most graceful and elegant images, where surface detail is minimized in favor of overall design and fluidity of line.

Although other works in the "deer" series appear to be in editions as large as six, only five bronzes of *Standing Buck* are currently known. The others are in the Museum of Art, Rhode Island School of Design, Providence, The Fine Arts Museums of San Francisco, California (Hélène Irwin Fagan Collection), and two in private collections, New York.

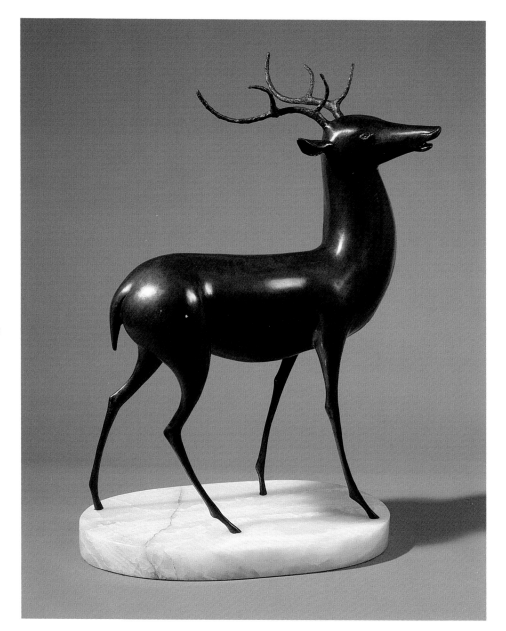

ELIE NADELMAN (1882-1946)

43. Chanteuse

Cherry wood, partially painted, 37 in. high

Model executed about 1918

EXHIBITED: Whitney Museum of American Art, New York, 1975, *The Whitney Studio Club and American Art 1900-1932*, p. 23 [n.n.], lent by Lloyd Goodrich // Whitney Museum of American Art, New York, and the Hirshhorn Museum and Sculpture Garden, Smithsonian Institution, Washington, D.C., 1975-76, *The Sculpture and Drawings of Elie Nadelman* (text by John I.H. Baur), pp. 67 no. 61, 69 no. 61 illus., lent by Lloyd Goodrich // Whitney Museum of American Art, New York, 1977, *20th-Century American Art from Friends' Collections*, [n.p.] [n.n.], lent by Lloyd Goodrich

EX COLL.: Lloyd Goodrich, New York, until 1986; to his estate, until 1987

In December 1917 a group of society women and conservative women sculptors organized a war charity exhibition entitled "Allies of Sculpture" on the roof garden of the Ritz-Carlton, New York. Nadelman, who was then the toast of the New York art world, submitted four examples of his new work, tinted plasters of contemporary figures, among which were *La Femme Assise* (*The Hostess*), *Adolescent* (a sprightlier, naked version of *The Man in the Open Air*), and a work called *Concert Singer* (destroyed), the forerunner to this *Chanteuse*, both in composition and in spirit [*cf.* Lincoln Kirstein, *Elie Nadelman* (1973), (n.p) pl. 93]. The exhibition of these works caused an extraordinary scandal; the conservative critics and public alike were shocked at Nadelman for showing women in contemporary garb alongside naked men.

Three other wood carvings of this *Chanteuse* are known, all of which are privately owned. They differ slightly from one to the next in the handling of paint on the figure's face and neck.

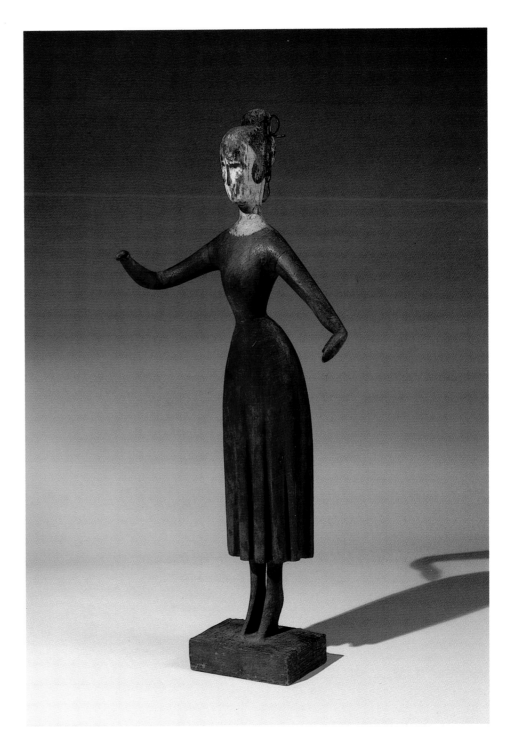

ELIE NADELMAN (1882-1946)

44. Dancer

Cherry wood, 28¼ in. high

Model executed about 1918-19

RECORDED: Lincoln Kirstein, *Elie Nadelman Drawings* (1970), p. 52 no. 51, as "Collection: Mrs. David M. Levy" [*sic*] // *cf.* Lincoln Kirstein, *Elie Nadelman* (1973), pp. 149 no. 72, 296-97 no. 100, [n.p.] pl. 72 // *cf.* Whitney Museum of American Art, New York, *The Sculpture and Drawings of Elie Nadelman* (1975, text by John I.H. Baur), pp. 9, 14, 72 no. 65 illus., 67 no. 65, illus. in color on front cover

EXHIBITED: The Museum of Modern Art, New York, 1948, *The Sculpture of Elie Nadelman* (text by Lincoln Kirstein), pp. 33 illus., 62 no. 19, lent by Dr. and Mrs. David M. Levy // Whitney Museum of American Art, New York, 1976, *200 Years of American Sculpture*, pp. 146 no. 214 illus., 343 no. 168, lent by private collection

EX COLL.: Dr. and Mrs. David M. Levy, New York, by 1948; by gift to United Jewish Appeal, New York, benefit auction, 1949, sold for $1,100.00; to private collection, New York, 1949-89

Nadelman first exhibited a version of this *Dancer*—either the tinted plaster model or a wood carving—in 1919 at Knoedler's Gallery, New York, along with other painted plasters and several cherry wood carvings. It was not the first time he had shown his new work—figures in contemporary costumes, with blue hair and other unusual details—but it was the first of this scope, the sculptures numbering sixteen. Two years earlier he had exhibited four tinted plasters and the critical reaction was quite negative. This time, the response was scathing. His patrons and public believed that he was making fun of them, and Nadelman was savagely attacked for his impertinence. Ironically, what today is regarded as among the most important and original sculptures ever created in this country was then considered to be in bad taste, trivial, insolent, decadent, and worse.

This *Dancer* is one of three known versions of the subject. The others, which are partially painted and gessoed, are in the Wadsworth Atheneum, Hartford, Connecticut, and a private collection, Santa Fe, New Mexico. In addition to the now-destroyed plaster model, Lincoln Kirstein cited [*Elie Nadelman* (1973), pp. 296-97 no. 100] only the Wadsworth Atheneum example, and erroneously stated

that it was the one that was shown in the 1948 Museum of Modern Art Nadelman exhibition. The illustration in the accompanying catalogue shows that it is an unpainted version that was included.

A closely related drawing titled *High Kicker*, c. 1917-19 (ink and ink wash on paper, 9 x 4½ in.), is in a private collection [*cf.* Kirstein (1970), no. 51 illus.]. According to Kirstein [p. 52], Nadelman had in his files a photograph of the vaudeville dancer Eva Tanguay posed in the identical position as this *Dancer*.

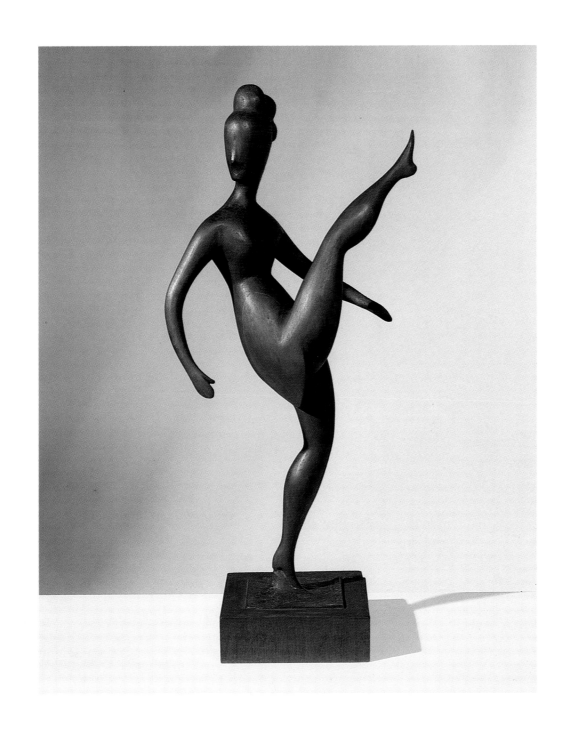

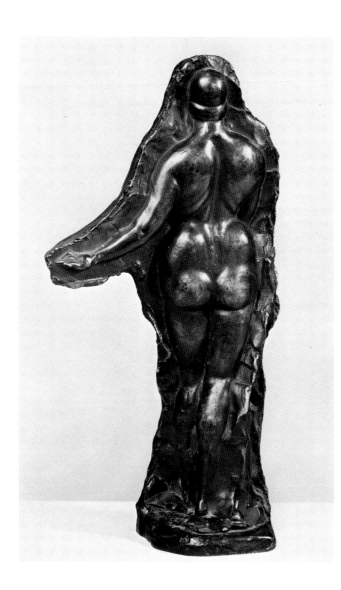

GASTON LACHAISE (1882-1935)

45. Relief of the Rear View of a Female Figure

Bronze, dark brown patina, 12 in. high

Signed (on the proper right side):
G. LACHAISE

Founder's mark (on the base): ROMAN
BRONZE WORKS N-Y-

Model executed about 1924

EXHIBITED: Hirschl & Adler Galleries, New York, 1986, *Modern Times: Aspects of American Art, 1907-1956*, p. 66 no. 58 illus. in color

EX COLL.: the sculptor; to Arthur F. Egner, South Orange, New Jersey; by descent to Emily Egner Madden, until 1986

As in so much of Lachaise's work, this figure was inspired by the sculptor's wife Isabel. Lachaise himself wrote: "At twenty in Paris I met a young American person who immediately became the primary inspiration which awakened my vision and the leading influence that has directed my forces" [quoted in Hilton Kramer, et al., *The Sculpture of Gaston Lachaise* (1967), pp. 9-10]. The many depictions of women in Lachaise's art—from the monumental to the modestly-scaled, from the simply-posed to the erotic, even grotesque images of his late work—all stem from Lachaise's "attempt to encompass and to celebrate the force [Isabel] represented in his life" [*ibid.*, p. 10].

This work relates to other high reliefs of female nudes that Lachaise executed during the mid-twenties [*cf.* Los Angeles County Museum of Art, California, *Gaston Lachaise 1882-1935: Sculpture and Drawings* (1963), (n.p.) nos. 42 and 65 illus.].

According to John B. Pierce, Jr., of the Lachaise Foundation, this bronze, a lifetime cast, is the only example of *Relief of the Rear View of a Female Figure* currently known.

JO DAVIDSON (1883-1952)

46. The Dance

Bronze, intaglio relief, antique green patina (repatinated to replicate original patina), 31⅛ x 42⅞ in.

Signed, dated, and inscribed (at lower right): JO DAVIDSON/CERET, 1915

Founder's mark (at lower left): ROMAN BRONZE WORKS N-Y-

According to Jacques Davidson, the sculptor's son, *The Dance* was commissioned as a stone carving by Irene Lewisohn for the Neighborhood Playhouse, New York [letter, Jacques Davidson to Susan Menconi, Hirschl & Adler Galleries, Dec. 27, 1980, Hirschl & Adler archives]. That work remains at the Playhouse to this day.

Several other versions of this model in various media are known: a cast stone example is in a private collection, California, a pewter version is in a private collection, France, and a bronze example, which is possibly the same as the present work, was listed and illustrated as lot no. 106 in an American Art Association, New York, auction catalogue of February 20, 1930.

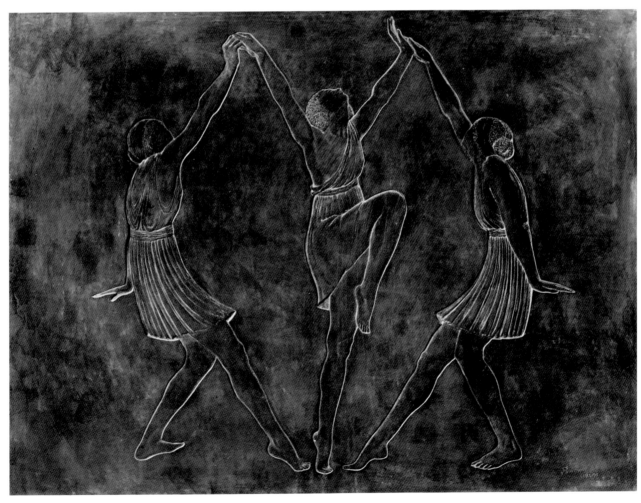

JO DAVIDSON (1883-1952)

47. Mask: Gertrude Stein

Terra cotta, 11 in. high (excluding original marble base)

Signed (on the back): Davidson

Model executed in 1923

RECORDED: *cf.* National Portrait Gallery, Washington, D.C., *Jo Davidson Portrait Sculpture* (1978), [n.p.][n.n.] illus. // *cf.* National Portrait Gallery, Washington, D.C., *Permanent Collection: Illustrated Checklist* (1980), p. 113 illus.

EX COLL.: the sculptor, until 1952; to his estate, until 1989

Jo Davidson was one of the most successful portraitists in the history of American sculpture. His list of sitters is highly impressive, ranging from Albert Einstein to John D. Rockefeller, from Franklin D. Roosevelt to Helen Keller, from George Luks to D.H. Lawrence.

None of his likenesses, however, is more imposing than his seated figure of Gertrude Stein (1874-1946), the innovative collector of modern art and experimental author of spare prose. Davidson had known Stein and her brother Leo since his first trip to Paris in 1907. He described her: "There was an eternal quality about her—she somehow symbolized wisdom" [Jo Davidson, *Between Sittings* (1951), p. 175]. Most of Davidson's portraits were simply heads or busts, but when it came to doing Gertrude Stein's, he revised that format, concluding [p. 174]: "To do a head of Gertrude was not enough—there was so much more to her than that. So I did a seated figure of her—a sort of modern Buddha."

The resulting seated portrait, contemplative and self-contained, with a rounded pose stressing the solidity of the sitter, has become an American icon—the quintessential portrait of Gertrude Stein. About the work, Stein characteristically noted: "that's Gertrude Stein, that's all of Gertrude Stein, that's all of Gertrude Stein there is" [quoted in National Portrait Gallery (1978), *op.cit.*].

This sensitive *Mask* is adapted from the full portrait of *Gertrude Stein*, and stands as a striking work of art in its own right. Another example of it, also in terra cotta, is in the collection of the National Portrait Gallery, Washington, D.C., along with a terra cotta of the full figure. A bronze of the whole figure is in the Whitney Museum of American Art, New York.

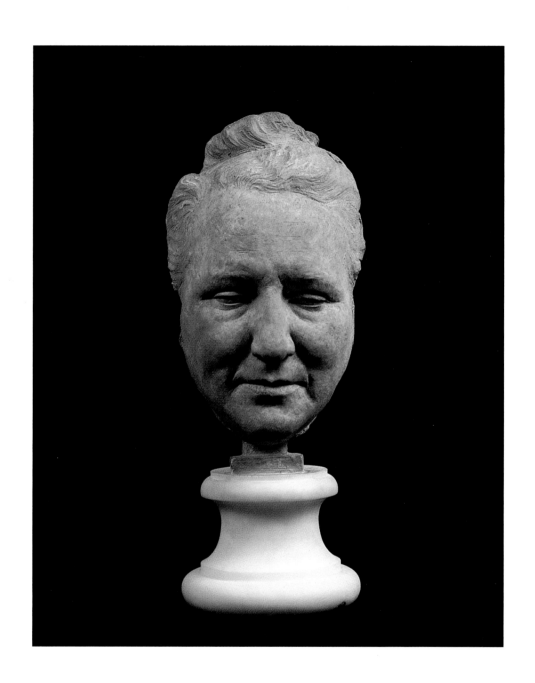

WILLIAM HUNT DIEDERICH
(1884-1953)

48. Antelope and Hound

Bronze, dark brown patina, 22 in. high x 26 in. wide x 10 in. deep

Signed and dated (on original marble base, at center): [artist's monogram] 1916

RECORDED: *cf.* Kingore Galleries, New York, *Catalogue of the First American Exhibition of Sculpture by Hunt Diederich* (1920), [n.p.] no. 61, as *Deer and Hound*

EX COLL.: Mrs. Washington Augustus Roebling, Trenton, New Jersey; by descent in the family to her grandson, South Carolina; to his widow, South Carolina, until 1988

The grandson of the Boston painter William Morris Hunt and grandnephew of the architect Richard Morris Hunt, William Hunt Diederich was born in Hungary on a vast estate managed by his father. He spent his boyhood in Switzerland, but moved with his mother to the United States around 1900 where they lived in his grandfather's house in Boston, Massachusetts. After traveling out West with the notion of becoming a cowboy and later studying at the Pennsylvania Academy of the Fine Arts, Philadelphia, the artist, who was known as Hunt, embarked on a cosmopolitan career that took him to Spain with Paul Manship in 1907, and on, alone, to Africa, Rome, Berlin, and to Paris, where he was to live for the next ten years.

Diederich's highly distinctive work is charac-terized by elegant, attenuated lines and arabesque curves, qualities which extend from his silhouetted paper cutouts, to his wrought iron utilitarian objects such as fire screens, chandeliers, and weathervanes, to his bronze sculptures in the round. As in this *Antelope and Hound* and *Playing Greyhounds* (cat. no. 49), his three-dimensional work combines sophisticated linear design with simplified, geometric planes. Diederich almost invariably depicted animals—elegant, nervous, and agile creatures, whose spirited movement is frozen in a moment of time.

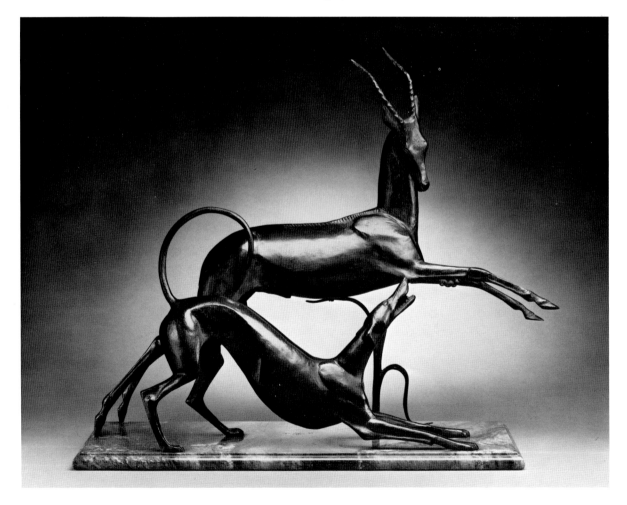

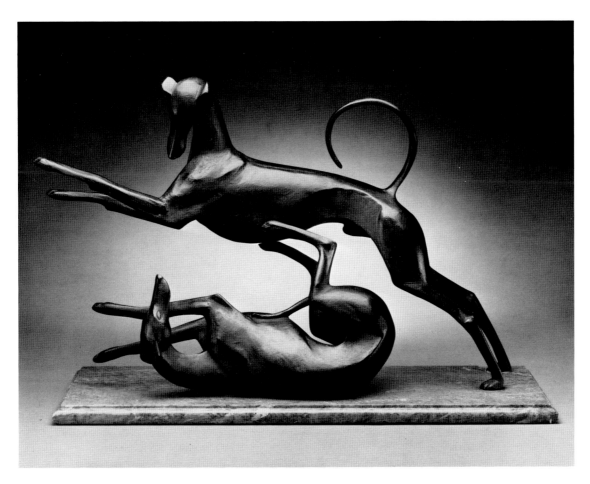

WILLIAM HUNT DIEDERICH
(1884-1953)

49. Playing Greyhounds

Bronze, dark brown patina, 15½ in. high x 25 in. wide x 10 in. deep

Model executed about 1913-16

RECORDED: *cf.* Kingore Galleries, New York, *Catalogue of the First American Exhibition of Sculpture by Hunt Diederich* (1920), [n.p.] no. 59, as *Playing Dogs*

EX COLL.: Mrs. Washington Augustus Roebling, Trenton, New Jersey; by descent in the family to her grandson, South Carolina; to his widow, South Carolina, until 1988

A closely related work is *Playing Dogs* (bronze, n.d., 14 x 30¼ x 11 in.), examples of which are in the Whitney Museum of American Art, New York, and the Seattle Art Museum, Washington. Presumably, either a version of that model or this *Playing Greyhounds* is the same as the work titled *Greyhounds*, which was exhibited at the Salon d'Automne, Paris, in 1913, and which first brought the artist wide critical recognition, resulting in many commissions.

For the most part, Diederich's work is not well documented. His 1920 Kingore Galleries show was one of the few American exhibitions he ever had (certainly it was the largest), and the accompanying catalogue had only a few illustrations. Further, most of the eighty-eight works included in the exhibition had generic titles, such as "Cats," "Donkey," or "Panther," and none had any indication of size or medium, so it is difficult to match those works with ones currently known. However, it is very likely that examples of both this *Playing Greyhounds* and the Whitney/Seattle sculpture were shown in the Kingore Galleries exhibition, the former as no. 59 (*Playing Dogs*) and the latter as no. 32 (*Running Hounds*).

Another version of this model, with minor variations, is in a private collection, Boston, Massachusetts.

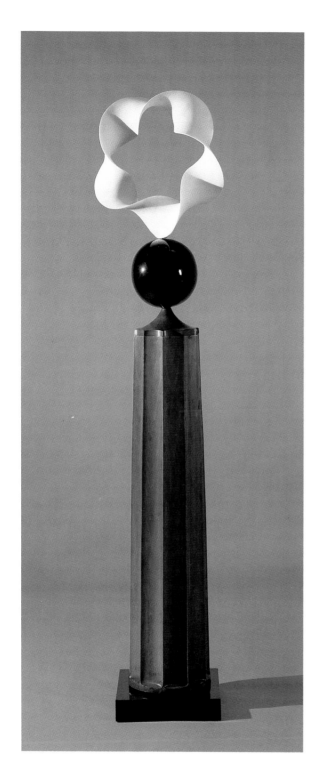

RUTHERFORD BOYD (1884-1951)

50. Moebius Strip in a Torus

Marble, ebonized wood, and Cuban mahogany, 76 in. high

Executed in 1943

RECORDED: *Life Magazine*, March 21, 1949, p. 18 illus.

EXHIBITED: Hirschl & Adler Galleries, New York, 1983, *Science into Art: The Abstract Sculpture and Drawings of Rutherford Boyd*, p. 22 no. 12 illus. in color

EX COLL.: the artist, until 1951; to his estate, until 1983; to [Hirschl & Adler Galleries, New York]; to private collection, 1983-89

Throughout the late 1930s and 1940s Rutherford Boyd produced an extensive body of sculpture in various media, including exotic woods, plaster, stone, lucite, and aluminum. Departing from the traditional representationalism of his earlier paintings and drawings, his sculptures, based on principles of planar geometry and mathematics, are totally abstract.

Consistent with the form of a moebius strip, the marble component on this sculpture has one continuous surface and a single, unbroken edge. Mounted on an ebonized sphere and fluted carved wood column, designed and executed by the artist, this work is one of the largest and most complex of all of Boyd's sculptures. It represents the culmination of his interest in the application of mathematical and geometric principles to art.

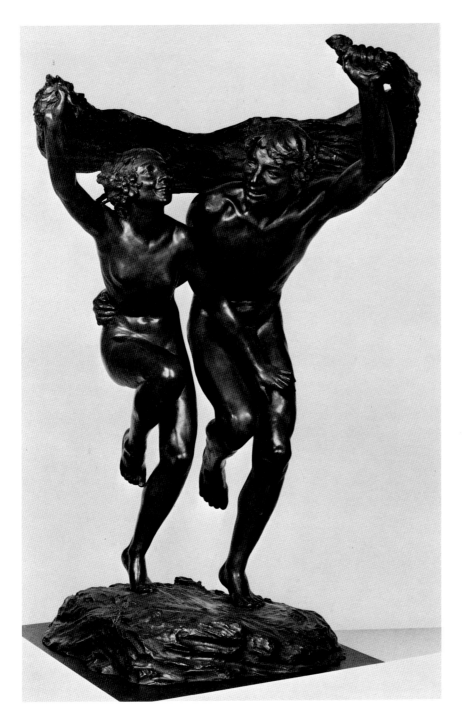

MALVINA HOFFMAN (1885-1966)

51. Bacchanale Russe

Bronze, greenish-black patina, 40⅝ in. high

Signed, dated, and inscribed (on top of base): MALVINA HOFFMAN/ © 1917.

Founder's mark (on back side of base): ROMAN BRONZE WORKS N-Y-

Model executed in 1912

EXHIBITED: California Palace of the Legion of Honor, San Francisco, and The Block Gallery, Northwestern University, Evanston, Illinois, 1981-82, *Pavlova!*, [no cat.] // Hirschl & Adler Galleries, New York, 1988, *Adventure & Inspiration: American Artists in Other Lands*, p. 107 no. 68 illus.

EX COLL.: Colonel Philippe Bunau-Varilla, Paris, France, in 1920; private collection, Houston, Texas

Bacchanale Russe depicts Anna Pavlova and Mikhail Mordkin dancing in the "Autumn Bacchanale" section of Glazunov's *Seasons*, a ballet which Malvina Hoffman had seen them perform in London in 1910 and which had greatly affected the sculptor. It was the source of inspiration for a large number of her works.

Hoffman originally modeled *Bacchanale Russe* in a 14-inch size in 1912, when she was living in Paris; it was cast during her lifetime in an edition of nine bronzes. By 1917 the sculptor had enlarged the work to a height of nearly six feet. Two bronzes were cast in that scale. One was placed in the Luxembourg Gardens, Paris, but was subsequently destroyed during the German Occupation of World War II, and the other was purchased by Henry G. Dalton of Bratenahl, Ohio, who gave it in 1943 to the Cleveland Museum of Art, Ohio, where it remains today.

Although the sculptor planned an edition of six bronzes in this intermediate size, only two were made before the plaster model was destroyed in a fire at the foundry. This bronze, the first of the two, was purchased in January 1920 by Colonel Philippe Bunau-Varilla of Paris, the father of one of Hoffman's good friends. The other example remained in the collection of the artist until 1964, when she sold it to Eric L. Harvie. That version is now in the collection of the Glenbow-Alberta Institute, Calgary, Canada.

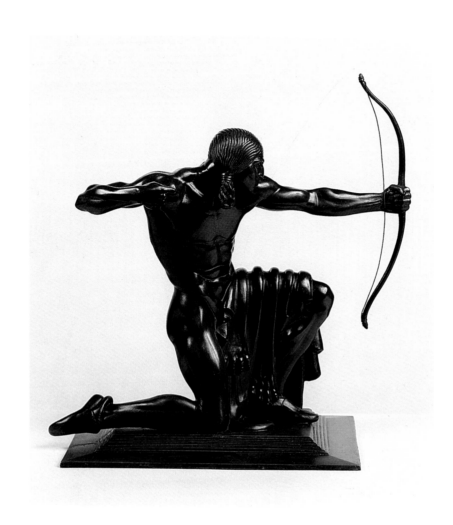

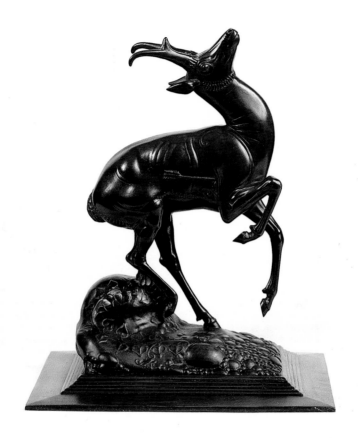

PAUL HOWARD MANSHIP (1885-1966)

52a. Indian

Bronze, dark brown patina, 13 in. high

Signed, dated, and inscribed (on the base):
PAVL MANSHIP/© 1914

52b. Pronghorn Antelope

Bronze, dark brown patina, 12⅛ in. high

Signed, dated, and inscribed (on the base):
© 1914/PAVL MANSHIP

RECORDED: *cf.* Albert E. Gallatin, *Paul Manship: A Critical Essay on his Sculpture and an Iconography* (1917), p. 13 // *cf.* Paul Vitry, *Paul Manship, Sculpteur Américain* (1927), p. 37, [n.p.] pls. 31 and 32 // *cf.* Edwin Murtha, *Paul Manship* (1957), p. 152 nos. 51 and 52, [n.p.] pls. 12 and 13 // *cf.* Minnesota Museum of Art, Saint Paul, *Paul Manship: Changing Taste in America* (1985), pp. 136-37 nos. 97 and 98 illus. // Michael Forest, *Art Bronzes* (1988), p. 270 nos. 5.37 and 5.38 illus.

EXHIBITED: Hirschl & Adler Galleries, New York, 1986, *From the Studio: Selections of American Sculpture 1811-1941*, pp. 52-53 nos. 33a and 33b illus. in color

EX COLL.: estate of William J. Murphy, New York

This pair was produced in bronze in an edition of fifteen, as recorded by Gallatin, Vitry, and Murtha [*loc. cit.*]. Other examples are in the collections of The Metropolitan Museum of Art, New York, The Art Institute of Chicago, Illinois, the National Museum of American Art, Washington, D.C., The Saint Louis Art Museum, Missouri, Smith College Museum of Art, Northampton, Massachusetts, and Pratt Institute, Brooklyn, New York.

PAUL HOWARD MANSHIP (1885-1966)

53. Flight of Night

Bronze, dark brown patina, 26½ in. high
(excluding original stepped marble base),
36 in. high (overall)

Signed, dated, and inscribed (on the ball):
PAUL MANSHIP © 1916

Founder's mark (on the ball): ROMAN
BRONZE WORKS N-Y-

RECORDED: *cf.* Albert E. Gallatin, *Paul Man-ship: A Critical Essay on his Sculpture and an Iconography* (1917), pp. 5, 15, [n.p.] illus. // *cf.* Edwin Murtha, *Paul Manship* (1957), pp. 14, 153 fig. 2, 158 no. 81, incorrectly sized at 37 in. high excluding marble base // *cf.* Minnesota Museum of Art, Saint Paul, *Paul Howard Manship: an intimate view* (1972), pp. 25 no. 16S illus., 52 no. 16 // *cf.* Minnesota Museum of Art, Saint Paul, *Paul Manship: Changing Taste in America* (1985), p. 71 no. 44 illus., illus. in color on front cover

EXHIBITED: Hirschl & Adler Galleries, New York, 1986, *Modern Times: Aspects of American Art, 1907-1956*, pp. 72-73 no. 65 illus. in color

EX COLL.: Mrs. Rodney Chase, Watertown, Connecticut, about 1925–until 1986 (probably acquired from Milch Gallery, New York)

One of Manship's earliest and most ardent supporters was Albert Gallatin, influential art critic and himself an artist. In 1917 Gallatin published a book on Manship's work, and noted that among Manship's inspirations was "the creative period of Indian art" [*op. cit.*, p. 3]. Gallatin continued [p. 5]: "The lessons the artist has learned from Indian art, particularly from Hindu and Buddhist sculpture, one perceives in such examples as the very graceful Dancer and Gazelles, Sundial—Time and Hours, and The Flight of Night. In these one sees the significance that the artist attaches to gesture." In *Flight of Night*, the influence of Indian art is also evident in the careful attention to decorative detail, the pose of a figure moving through space, and, most importantly, the emphasis on silhouette and purity of outline. As the critic Royal Cortissoz remarked: "In Manship the silhouette is triumphant" [quoted in Murtha, *op. cit.*, p. 14].

According to Edwin Murtha [*ibid.*, p. 158], *The Flight of Night* was cast in an edition of six bronzes in this large size. Other examples are in the collections of the Corcoran Gallery of Art, Washington, D.C. (dated 1918), the Toledo Museum of Art, Ohio, and the Minnesota Museum of Art, Saint Paul. The image was also made in reduction (14⅜ in. high, excluding marble base) in an edition of twenty.

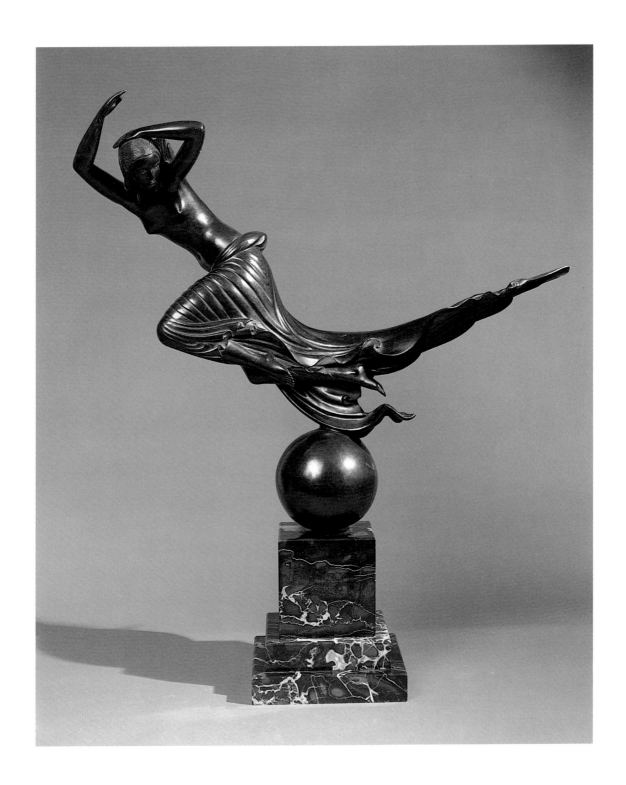

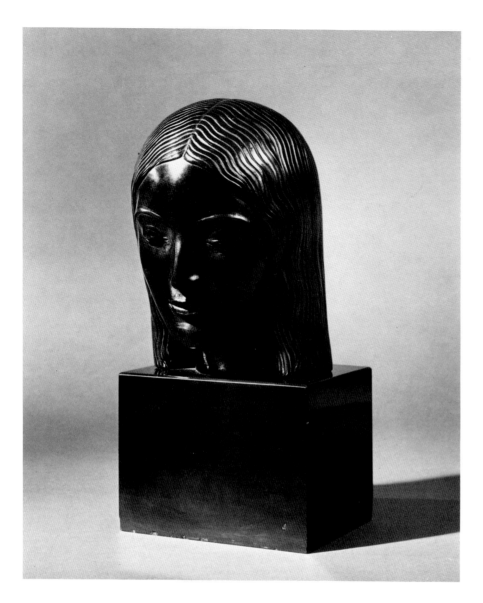

PAUL HOWARD MANSHIP (1885-1966)

54. Head of a Girl

Bronze, black patina, 9¾ in. high (excluding original Belgian black marble base)

Model executed in 1916

RECORDED: *cf.* Paul Vitry, *Paul Manship, Sculpteur Américain* (1927), [n.p.] pl. 18 // *cf.* Edwin Murtha, *Paul Manship* (1957), p. 158 no. 83

As noted by Edwin Murtha [*loc. cit.*], this bronze is a study for the life-size bronze sculpture titled *Dancer and Gazelles*, 1916 (Corcoran Gallery of Art, Washington, D.C., and Toledo Museum of Art, Ohio). Murtha wrote about the large grouping [p. 158 no. 84]: "This is one of Manship's finest creations, perfectly conceived in form, and of the most elegant surface finish..."

Other examples of this head are in the collections of the Honolulu Academy of Arts, Hawaii, and The Virginia Museum of Fine Arts, Richmond.

PAUL HOWARD MANSHIP (1885-1966)

55. Dancing Child

Gilded plaster, 12½ in. high

Model executed in 1926-27

RECORDED: *cf.* Edwin Murtha, *Paul Manship* (1957), [n.p.] pl. 98, p. 169 no. 205

EX COLL.: the sculptor; by gift to the architect Eric Gugler; by bequest to his niece, Lydia Ratcliff, Chester, Vermont, until 1987; to private collection, Burlington, Vermont, until 1988

This *Dancing Child* is part of a group of four related figures that Manship made as finials to the balcony railing in the dining room of his home on East 72nd Street, New York. Also called "Charleston I, II, III, and IV," the *Dancing Child* figures on the railing itself, along with the bas reliefs of a man, woman, and child, were made of gilded bronze.

PAUL HOWARD MANSHIP (1885-1966)

56. Diana

Bronze, greenish-brown patina, with traces of gilding, 37½ in. high

Signed and dated (on bottom leaf, proper left): PAUL MANSHIP 1921 ©

Numbered (on bottom leaf, proper right): Nº 3

Founder's mark (on the base): ROMAN BRONZE WORKS N-Y-

RECORDED: *cf.* Paul Vitry, *Paul Manship: Sculpteur Américain* (1927), p. 42 [n.n.], as executed in 1920 // *cf.* Edwin Murtha, *Paul Manship* (1957), pp. 161-62 no. 138, another size illus. as pl. 26 // *cf.* Minnesota Museum of Art, Saint Paul, *Paul Howard Manship: an intimate view* (1972), p. 55 no. 26, 46 illus. // Alistair Duncan, *American Art Deco* (1986), pp. 208-09 this version illus. in color

EX COLL.: [sale no. 5372, Christie's, New York, June 3, 1983, *American Paintings, Drawings and Sculpture of the 18th, 19th and 20th Centuries*, p. 204 lot 245 illus. in color]; to [Hirschl & Adler Galleries, New York, 1983]; to Investment Mortgage International, San Francisco, California, 1983-85; to [sale, Butterfield & Butterfield, San Francisco, California, June 20, 1985, lot 3339]; to [Hirschl & Adler Galleries, New York, 1985]; to private collection, California, 1985-89

Diana and its companion *Acteon* were originally conceived in this size. Manship then enlarged the two sculptures in 1924 to monumental scale, and in 1925 made slightly smaller than life-size versions of them.

According to Paul Vitry [*loc. cit.*], twelve bronzes of *Diana* were cast in this original size, other examples of which are in the collections of the Museum of Art, Carnegie Institute, Pittsburgh, Pennsylvania, the Isabella Stewart Gardner Museum, Boston, Massachusetts, and the Minnesota Museum of Art, Saint Paul.

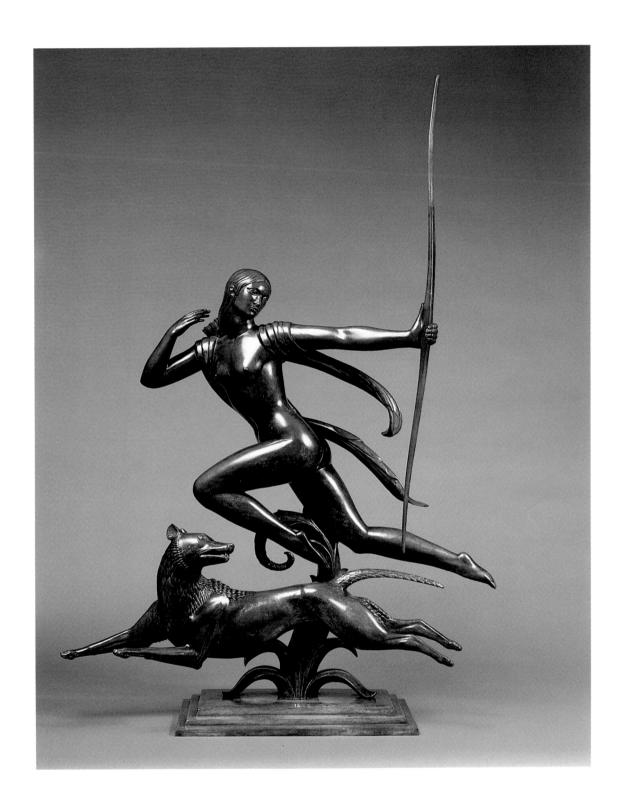

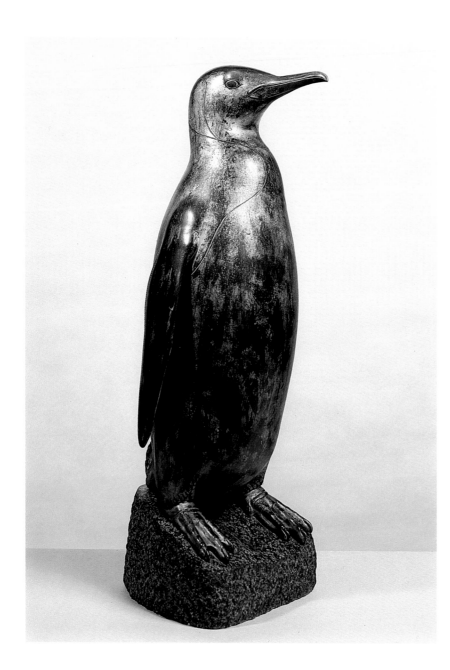

PAUL HOWARD MANSHIP (1885-1966)

57. King Penguin

Gilded bronze, 31 in. high (including original pink granite base)

Model executed in 1932

RECORDED: *cf.* Edwin Murtha, *Paul Manship* (1957), pp. 155 fig. 8, 178 no. 315 // *cf.* Minnesota Museum of Art, Saint Paul, *Paul Manship: Changing Taste in America* (1985), p. 81 no. 53 illus. in color

EXHIBITED: Hirschl & Adler Galleries, New York, 1986, *From the Studio: Selections of American Sculpture 1811-1941*, pp. 70-71 no. 46 illus. in color // Hirschl & Adler Galleries, New York, 1986, *Modern Times: Aspects of American Art, 1907-1956*, pp. 74-75 no. 66 illus. in color

EX COLL.: [Kennedy Galleries, New York, 1967-68]

King Penguin is one of ten birds that Manship created to form a part of the elaborate Paul J. Rainey Memorial Gateway, the formal entrance to the New York Zoological Park, Bronx Zoo, New York. The gateway, officially dedicated in 1934, was commissioned by Mrs. Grace Rainey Rogers in memory of her brother, the big-game hunter, explorer, motion-picture photographer, and benefactor of the Zoo.

Manship worked on the gates with fifteen assistants over a five-year period, both in Paris and New York. The birds, which are perched in the foliage on each side of the two openings, were modeled in 1932. About these works, Edwin Murtha wrote [*op. cit.*, p. 177 nos. 302-31]: "Manship's skill as an *animalier* is . . . particularly impressive in these details from the Bronx Zoo Gates. For sheer elegance of finish the small gilded figures of the ten birds rank with the best he has done."

In the 1985 Minnesota Museum of Art catalogue [*loc. cit.*], Leanne A. Klein observed about the *King Penguin*: "There is a subtle humor apparent in both the jauntily cocked head, and the military posture. The animal stands smartly at attention, flightless wings neatly folded at its sides, as if awaiting the orders of a superior in rank."

This bronze is the same scale as the penguin on the Rainey Gates. A third example in this size, also unsigned, is in the collection of Brookgreen Gardens, Murrells Inlet, South Carolina. *King Penguin* was also made in reduction (approx. 11 in. high), signed by Manship and bearing the initials of Angelo Colombo, an assistant who worked with Manship on the commission.

PAUL HOWARD MANSHIP (1885-1966)

58. Garden of Eden—Sundial

Bronze, light greenish-brown patina; 36¼ in. high

Signed, dated, and inscribed (on the base): ©/•PAUL•MANSHIP•SCULP•1941•

Founder's mark (on the base): Bedi-Rassy Art FDRY N.Y.C.

RECORDED: *cf.* The National Sculpture Society, New York, *American Sculptor Series, Book 2: Paul Manship* (1947), p. 51, as 1943 [*sic*] // *cf.* Edwin Murtha, *Paul Manship* (1957), p. 182 no. 420, [n.p.] pl. 94

EXHIBITED: Hirschl & Adler Galleries, New York, 1986, *Modern Times: Aspects of American Art, 1907-1956*, p. 71 no. 64 illus. in color

EX COLL.: the sculptor; to Marie Louise Speed, Lexington, Kentucky; to her estate; to [sale, Auctions Unlimited, Lexington, Kentucky, *The Estate of Marie Louise Speed*, March 11, 1983]; to private collection, Kentucky, until 1986

According to John Manship, the sculptor's son, *Garden of Eden—Sundial* was cast in an edition of six or more bronzes. Another example is in the collection of the National Museum of American Art, Washington, D.C., and a third is in a private collection, Pennsylvania.

This bronze is accompanied by a copy of the 1947 American Sculpture Society monograph on Manship inscribed with a dedication from the sculptor to the first owner of the work, Marie Louise Speed. Miss Speed was a cousin of J.B. Speed, founder of the J.B. Speed Art Museum, Louisville, Kentucky.

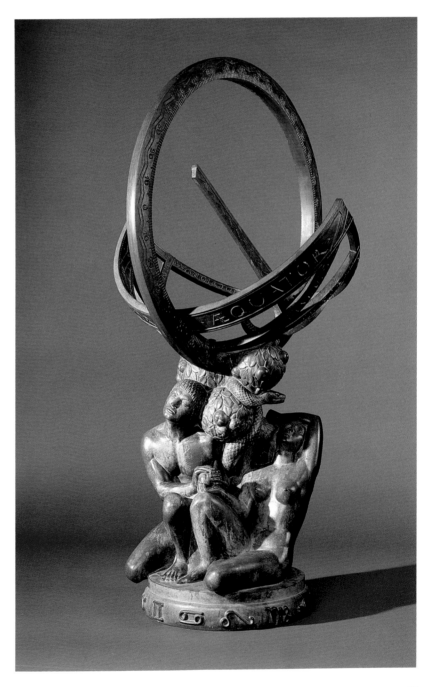

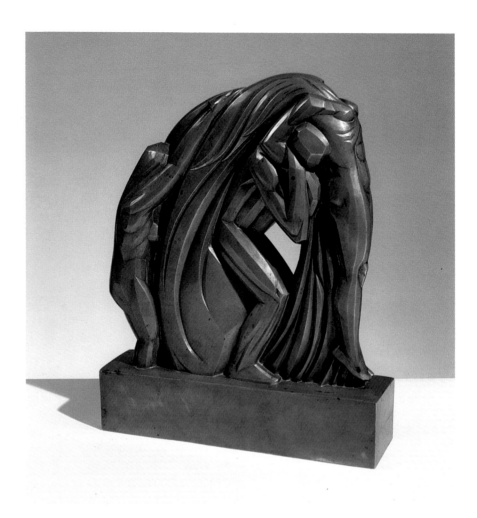

JOHN STORRS (1885-1956)

59. Three Figures (Bathers)

Bronze, natural patina, 14⅛ in. high x 11½ in. wide x 3 in. deep

Signed, dated, and inscribed (on the base): JOHN/STORRS/PARIS/•1916•/•1919•

RECORDED: *cf.* Whitney Museum of American Art, New York, *John Storrs* (1986, text by Noel Frackman), pp. 39-40 fig. 29, as "whereabouts unknown," 54 fn. 1

EXHIBITED: Hirschl & Adler Galleries, New York, 1988, *Adventure & Inspiration: American Artists in Other Lands*, pp. 154-55 no. 108 illus. in color

John Storrs spent much of his adult life in France. Beginning in 1906-07, and again from 1911 onward, Storrs lived in Paris, where he studied sculpture at various art schools and ateliers. Around 1912 he took lessons from the great Rodin, who became a close friend and mentor but who appears not to have had a long-lasting influence on Storrs' style. Instead, it was the artistically charged atmosphere of Paris during these years, where the new and revolutionary styles of Cubism and Futurism were emerging, that affected the development of the young sculptor.

Three Figures (Bathers) incorporates aspects of Cubism in the breaking-up of the planes and Futurism in the force lines used to heighten the sense of motion and elegance. However, the figures remain solid and identifiable and do not completely fracture under the force of movement.

Until the recent discovery of this bronze, *Three Figures (Bathers)* was known only through contemporary references and an archival photograph [*cf.* Whitney Museum, *op. cit.*, p. 40 fig. 29]. The John Storrs' Papers [Archives of American Art, Smithsonian Institution, Washington, D.C.] indicate that the sculptor intended to cast the image twice, in two different sizes, though it was not specified how large the other version was meant to be, or if it was ever executed.

JOHN STORRS (1885-1956)

60. Modern Madonna

Polychromed terra cotta, 23 in. high

Signed (on the base, at back): STORRS

Model executed about 1918

RECORDED: *cf.* Michael Edward Shapiro, "Twentieth Century American Sculpture," in *The Bulletin of The Saint Louis Art Museum*, XVIII (Winter 1986), p. 15 illus. // *cf.* Whitney Museum of American Art, New York, *John Storrs* (1986, text by Noel Frackman), p. 21 fig. 8

EX COLL.: the sculptor; by gift to a private collection, until 1989

After the death of Storrs' beloved mother in 1913, the sculptor began to explore the mother and child theme in his work. Five years later, when his daughter was born in 1918, it evolved more specifically into this madonna and child image, which Storrs himself referred to as his "Modern Madonna" [Whitney Museum, *loc. cit.*]. Executed in terra cotta, the *Modern Madonna* was made in two different sizes, the present work being the larger of the two. Another example in this size, which does not display the vivid polychromy of this example, is in the collection of The Saint Louis Art Museum, Missouri. Reduced versions (11⅛ in. high) are in a private collection, Iowa, and the collection of Mr. and Mrs. Alvin S. Lane, New York.

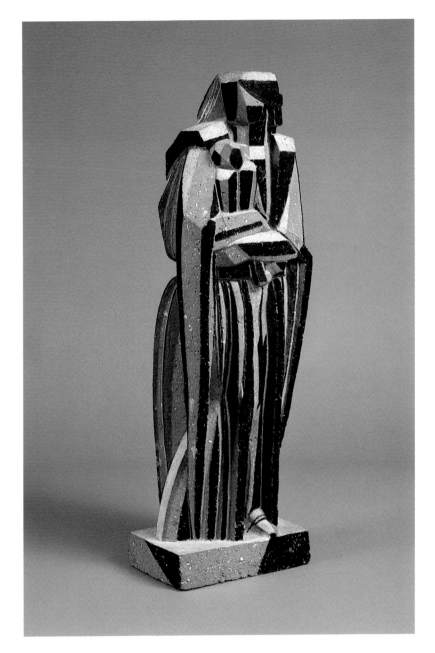

JOHN STORRS (1885-1956)

61. Abstract Forms #3 (Mourners)

Composite stone, 20½ in. high x 12 in. wide
x 5 in. deep

Executed about 1919

RECORDED: Alexander Brook, "March
Exhibitions: John Storrs at the Société Ano-
nyme," in *The Arts*, 3 (March 1923), p. 212
illus. // Joan M. Marter, Roberta K. Tarbell,
and Jeffrey Wechsler, *Vanguard American
Sculpture 1913-1939* (1979), pp. 34-35 fig. 42,
as *Abstract Forms #3*, dates as 1922

EXHIBITED: Société Anonyme, New York,
and Arts Club of Chicago, Illinois, 1923,
Exhibition of Sculpture by John Storrs // Sterling
and Francine Clark Art Institute, Wil-
liamstown, Massachusetts, 1980, *John Storrs
& John Flannagan: Sculpture & Works on Paper*,
pp. 15 illus., 48 no. 9, as *Abstract Forms #3*,
dates as 1922

EX COLL.: the artist, until 1956; to his
estate, until 1989

According to Noel Frackman, who has done
extensive work on John Storrs, the central
figure in this sculpture is nearly identical to
the woman in Storrs' color lithograph in red
and black titled *Three Figures* of 1917
(9⅟16 x 7¹⁵⁄16 in., collection of the Yale Univer-
sity Art Gallery, New Haven, Connecticut).
The year of that lithograph suggests a date in
the late teens for this carving.

The meaning of the work remains elusive.
Frackman has indicated that its original
title—if any—is not known; neither *Mourn-
ers* nor *Abstract Forms #3* appears to be the
original, although each over the years has
been variously associated with the work. In
1918 Storrs wrote a poem which would seem
to describe this carving, if not illluminate its
iconography [quoted in Sterling and Fran-
cine Clark Art Institute, *loc. cit.*, spelling
corrected here]:

> Through the blue gray
> veil of the hanging fog—
> all forms lose their planes
> and mass up—flat
> and colorless.
> one upon the other
> They lose their third dimension
> and become but silhouettes
> sliding.. moving in
> profile one across
> another

JOHN STORRS (1885-1956)

62. Le Sergent de Ville (Gendarme)

Plaster and black paint, 13½ in. high

Signed and inscribed (on the base): js/[illeg.]

Model executed about 1920

RECORDED: *cf.* Museum of Contemporary Art, Chicago, Illinois, *John Storrs (1885-1956): A Retrospective Exhibition of Sculpture* (1976), p. 17 [n.n.] // *cf.* Whitney Museum of American Art, New York, *John Storrs* (1986, text by Noel Frackman), pp. 52 fig. 50, 54, 138

EXHIBITED: Hirschl & Adler Galleries, New York, 1988, *Adventure & Inspiration: American Artists in Other Lands*, p. 153 no. 107 illus. in color

EX COLL.: estate of the artist; to [Robert Schoelkopf Gallery, New York]; to private collection, New York, until 1987

By the late teens Storrs had begun sculpting works that were architectonic in feeling and often laced with a wry sense of humor. *Le Sergent de Ville (Gendarme)*, with its air of self-importance so characteristic of a French policeman, displays Storrs' continued exploration of Cubism in the block-like forms and geometric planes enhanced by the use of black paint.

A bronze example, heightened with silver, of *Le Sergent de Ville (Gendarme)* is in the collection of the Corcoran Gallery of Art, Washington, D.C.. A large version (41½ in. high), executed in stone with enamel, is in the Musée Régional, Arts et Traditions de l'Orléanais, Château Dunois, Beaugency, France. In addition, at least two variations of the subject are known [*cf.* Whitney Museum, *op. cit.*, p. 52 figs. 51, 52].

WILLIAM ZORACH (1887-1966)

63. Family Group, a pair of panels

Brazilian walnut reliefs, each 66⅜ x 24½ in.

Executed in 1925

RECORDED: Paul S. Wingert, *The Sculpture of William Zorach* (1938), pp. 61, 72 no. 37, pl. 20, dates as 1927 // ("Mother and Child" panel only) Chaim Gross, *The Technique of Wood Sculpture* (1965), p. 36 fig. 40 // Roberta K. Tarbell, "Catalogue Raisonné of Willliam Zorach's Carved Sculpture," (Ph.D. dissertation, University of Delaware, Newark, 1976; University Microfilms, 1985), II, pp. 610-12 no. 200, 613-15 no. 201

EXHIBITED: C.W. Kraushaar Art Galleries, New York, 1928, *Exhibition of Sculpture by William Zorach*, nos. 15 and 16 // The Brooklyn Museum, New York, 1928-29, *Ninth Annual Exhibition of Paintings and Sculpture by the New Society of Artists*, nos. 195 and 196 illus. // The Museum of Modern Art, New York, 1930-31, *Painting and Sculpture by Living Americans*, no. 131 // Wilmington Society of the Fine Arts, Delaware, 1936, *Contemporary Sculpture*, no. 5 // Cincinnati Art Museum, Ohio, 1938, *Crafters Co. Exhibition* // Art Students League, New York, 1950, *Zorach: Retrospective Exhibition to Celebrate His Twenty-First Year at the Art Students League of New York*, no. 1 // Marion Koogler McNay Art Institute, San Antonio, Texas, 1956, *William Zorach* // American Academy of Arts and Letters, New York, 1969, *William Zorach: Memorial Exhibition: Sculpture, Drawings and Watercolors*, no. 6 // Bernard Danenberg Galleries, New York, 1970, *Zorach: Fifty Years of Watercolor*, no. 7 illus. // William A. Farnsworth Library and Art Museum, Rockland, Maine, Colby College Museum of Art, Waterville, Maine, and Worcester Art Museum, Massachusetts, 1980-81, *William and Marguerite Zorach: The Maine Years* (text by Roberta K. Tarbell), pp. 31-32, 48 nos. 4 and 5 // Summit Art Center, New Jersey, 1983, *William Zorach: Sculpture and Drawings* // Renwick Gallery, Washington, D.C., 1985, *Art Deco in America*

EX COLL.: the artist, until 1966; to his estate

About these works, Roberta K. Tarbell wrote [*op. cit.* (1980-81), pp. 31-32]:

> Although the large relief panels of 1925 are entitled *Family Group*, they are universal interpretations and not particularized representations of the Zorach family. The two Brazilian walnut reliefs are an extraordinary combination of flat patterned design (probably worked by Marguerite Zorach), rounded sculptural forms, and emotionally expressive symbolism.

The plaster models and full-size preliminary drawings for these panels are in the collection of the National Museum of American Art, Washington, D.C.

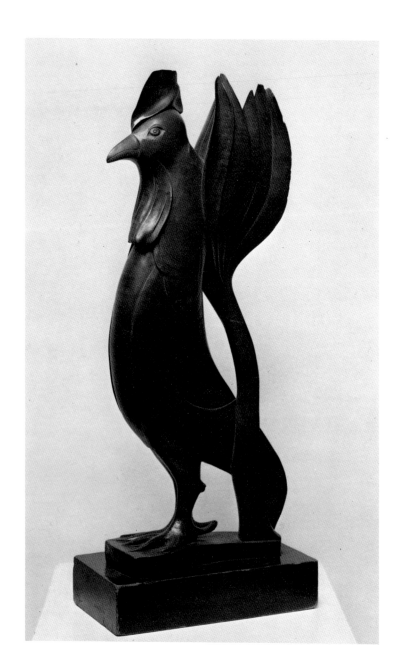

ROBERT LAURENT (1890-1970)

64. Rooster

Mahogany, 23½ in. high (excluding wooden base)

Signed (on the base): LAURENT

Executed about 1927

EXHIBITED: Queens Museum, New York, 1977, *American Sculpture, Folk and Modern*, no. 71 // Kraushaar Galleries, New York, 1988, *20th Century American Artists*, illus. on cover of announcement

EX COLL.: the sculptor; to Edith Gregor Halpert and [The Downtown Gallery, New York]; to the estate of Edith Gregor Halpert; to [sale no. 3520, Sotheby Parke Bernet, New York, May 16, 1973, *20th Century American Paintings and Sculpture: The Edith Gregor Halpert Collection (The Downtown Gallery), Part II*, (n.p.) lot 75 illus.]; to [Kraushaar Galleries, New York]; to private collection, until 1988

French by birth, Robert Laurent came to America at the encouragement of Hamilton Easter Field, a painter and influential patron of young artists. Laurent became Field's protégé, and together they established an important summer art colony in Ogunquit, Maine; the circle of artists there and in New York included Marsden Hartley, William Zorach, John Marin, Stefan Hirsch, Niles Spencer, and others.

The curving, flamelike composition of this *Rooster* is typical of Laurent's direct wood carvings of the late teens and twenties. Closely related works include *Flame*, 1917 (Whitney Museum of American Art, New York), *Swamp Lily*, 1921 (collection of John Laurent), and *Plant Forms*, 1922 (estate of the artist) [see: University of Durham, New Hampshire, *The Robert Laurent Memorial Exhibition* (1972-73, text by Peter V. Moak), nos. 14, 20, and 21 illus.].

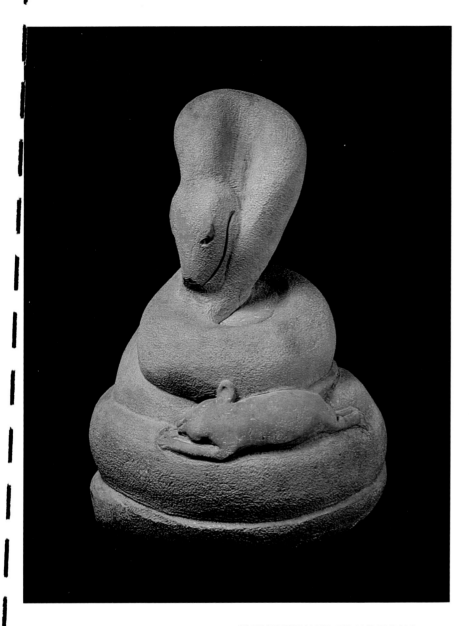

JOHN BERNARD FLANNAGAN
(1895-1942)

65. Snake

Limestone, 25⅜ in. high

Executed in 1938

RECORDED: Dick Siersema, *Rhyme and Reason* (1988, Dutch textbook), p. 174 illus., as *Cobra and Mongoose*

EXHIBITED: The Museum of Modern Art, New York, 1942, *The Sculpture of John B. Flannagan*, pp. 33 illus., 39 no. 33, lent by R. Sturgis Ingersoll // Whitney Museum of American Art, New York, 1976, *200 Years of American Sculpture*, pp. 143, 144 no. 209 illus., 339 no. 68, as *Cobra and Mongoose*, granite [*sic*] // Nassau County Museum of Fine Art, Roslyn, New York, 1981-82, *Animals in American Art*, [n.p.] no. 75 illus., as *Cobra and Mongoose* // Washington Square, Washington, D.C., 1984-85, *Animals! Tradition and Fantasy in Animal Sculpture*, [no cat.] // Hirschl & Adler Galleries, New York, 1986, *From the Studio: Selections of American Sculpture 1811-1941*, pp. 72-73 no. 47 illus. in color // Hirschl & Adler Galleries, New York, 1986, *Modern Times: Aspects of American Art, 1907-1956*, pp. 46-47 no. 38 illus. in color

EX COLL.: R. Sturgis Ingersoll, Philadelphia, Pennsylvania, by 1942; to his estate; to [sale no. 3617, Sotheby Parke Bernet, New York, March 21, 1974, lot l34 illus.]; to [Graham Gallery and Zabriskie Gallery, New York]

Snake was carved in 1938 and is one of Flannagan's last significant stone carvings. A year later he was hit by an automobile and seriously injured. He never fully recovered, despite several brain operations, and in the final years of life turned to working mostly in bronze.

Flannagan's sculptures are often endowed with universal and timeless themes. *Snake*, one of Flannagan's largest and most compelling works, evokes haunting images of predator and prey, the hunter and the hunted, the struggle between life and death. About his work, the sculptor wrote: "Often there is an occult attraction in the very shape of a rock as sheer abstract form. It fascinates with a queer atavistic nostalgia, as either a remote memory or a stirring impulse from the depth of the unconscious" ["The Image in the Rock," in *The Sculpture of John B. Flannagan* (1942), p. 7].

According to Robert S. Ingersoll [letter, Sept. 1, 1987, Hirschl & Adler archives], grandson of the original owner of this work, *Snake* was inspired by a visit that Flannagan and Sturgis Ingersoll made to the Philadelphia Zoo. A watercolor by Flannagan depicting a snake pursuing a rat served as the model for the sculpture and remains in the Ingersoll family. A photograph of that watercolor, which is personally dedicated to Sturgis Ingersoll, accompanies the sculpture.

American Folk Sculpture

The earliest American sculptures of the seventeenth and eighteenth centuries were simple carvings in stone or wood made by self-taught artisans, who have usually remained unidentified. These works generally had a functional purpose, and were made in rural areas of America, as well as cosmopolitan centers. As American scupture developed in the nineteenth century, academic sculptors looked to European models and traditions for inspiration, but folk artists, who by this time had expanded into a variety of different media and subject matter, showed a marked absense of pretense in their work. Still largely utilitarian in nature, the best of folk sculpture has an intuitive feeling for expressive form and a natural, sometimes whimsical and decorative style. There is a straightforwardness and inventiveness about these works which hold particular appeal to twentieth-century sensibilities.

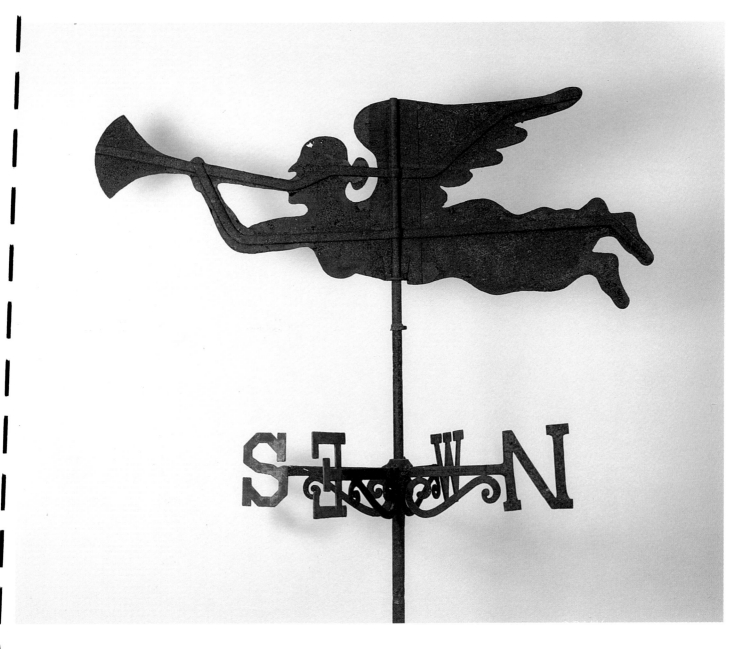

MAKER UNKNOWN, NEW ENGLAND

66. Angel Gabriel Weathervane

Sheet iron, with iron supporting braces, 96 in. high x 59 in. wide

Executed about 1800

At the end of the eighteenth century the angel Gabriel, the herald angel, became a popular image in America, representing the arrival of good times and a new-found liberty for the new nation. Given the gracefulness of its lines, it was especially popular as a weathervane for church spires.

This weathervane was made around 1800 in New England, probably in coastal Maine, where it was found on a church steeple. The horizontal lines of the figure are wonderfully balanced on the vertical axis so as to create a sense of weightlessness. It is complete with its original hand-wrought directionals. A closely related example is illustrated in the catalogue to the 1976 Whitney Museum of American Art, New York, exhibition, *200 Years of American Sculpture*, p. 83 pl. 21.

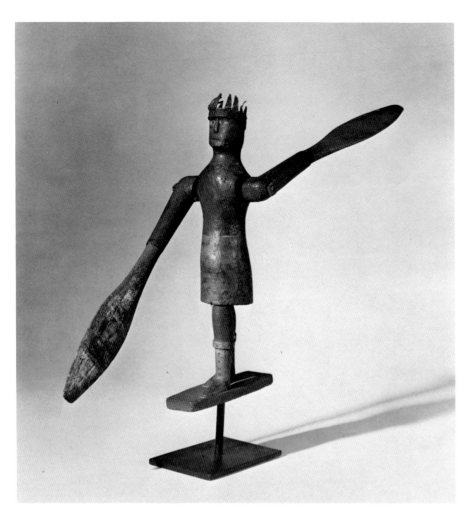

MAKER UNKNOWN, NEW ENGLAND

67. Indian Whirligig

Carved and polychromed wood, and metal, with original gold leaf, 16 in. high

Executed about 1825-50

EXHIBITED: Monmouth Museum and Monmouth Historical Association, Lincroft, New Jersey, 1975, *Masterpieces of American Folk Art*, [n.p.] illus.

Whirligigs were first introduced as a source of amusement in the nineteenth century. Due to their fragility, however, few from the first half of the century have survived. Remarkably, this primitive whirligig, dating from 1825-50, retains its original surface, including the metal bands on the figure's boots and the gold-leafed paddles. Intended as a wind toy, its abstract qualities take it far beyond its original functional purpose.

ATTRIBUTED TO JEREMIAH
DODGE (d. 1860)

68. Ship Chandler's Sign, A Merchant Seaman

Carved and polychromed wood, with tin hat,
86½ in. high x 33½ in. wide x 20 in. deep

Executed about 1845

EX COLL.: Mrs. William Wood, Kittery,
Maine, by 1909; to her son, William B.
Wood, "Ariston," Piqua, Ohio; to his estate,
until 1983; to private collection, until 1989

This sailor, which stood outside the entrance
to a store that supplied provisions to ships in
port, sports a vest and gold chain in a cos-
tume typical of the mid-1840s. The figure is
executed in carved wood; the hat is of heavy
gauge tin.

This figure is strongly reminiscent of the
style of Jeremiah Dodge, a ship carver who
worked at South Street and Market Slip,
New York. The treatment of the carving on
the head and beard is identical to the Dodge
carving of the *Hercules Figurehead* from the
U.S.S. *Ohio* [see: M.V. Brewington, *Shipcar-
vers of North America* (1962), p. 48 illus.; also:
Frederick Fried, *Artists in Wood* (1970),
pp. 83, 174, and 175].

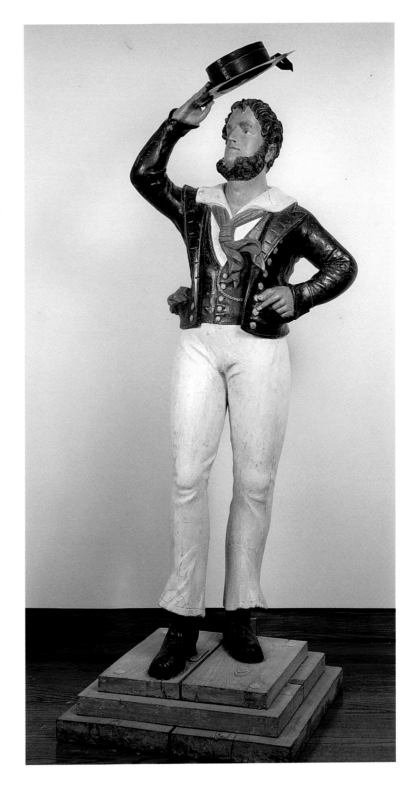

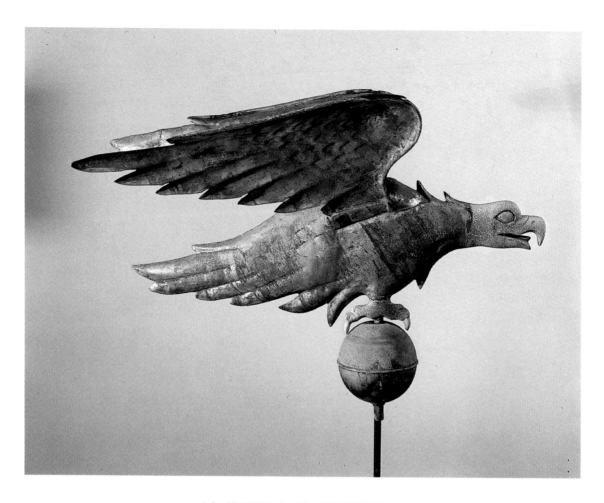

A.L. JEWELL & CO., WALTHAM,
MASSACHUSETTS (active 1852-1867)

69. Eagle Weathervane

Molded and sheet copper, with original gold
leaf, 20 in. high x 25 in. wide x 12 in. deep

Executed about 1860

In 1782 Americans selected the bald eagle as
their national emblem, signifying the incon-
querable will of the fledgling nation. They
took the theme from the Romans, choosing
the strong and determined spirit of the classi-
cal age. By the Civil War, many of the early
decorative motifs of the young nation had
fallen into disfavor, but the popularity of the
eagle had grown, along with a more stately
and impressive appearance.

Alvin Jewell of Waltham, Massachusetts,
the first production weathervane maker,
designed eagle weathervanes of this form in
five different sizes in 1860. A weathervane
similar to this one is illustrated as the front-
ispiece to Myrna Kaye, *Yankee Weathervanes*
(1975).

MAKER UNKNOWN, NEW YORK

70. Cigar Store Indian

Carved and painted wood, 38 in. high x 16½ in. wide x 12½ in. deep

Executed about 1860-70

The image of the Indian was quite popular as an advertisement for tobacco stores in Great Britain as well as the United States. Among the first to cultivate tobacco, American Indians introduced it to the settlers, and it soon made its way to England, where it achieved instant popularity.

This cigar store figure was fashioned after a southern Indian in his dress, stature, and dark skin, his feather headdress giving him a noble quality. The contraposto stance imparts a realistic appearance as he extends a hand to passersby. A tobacco barrel sits in back of him to the right, while two boxes of cigars stand on his left.

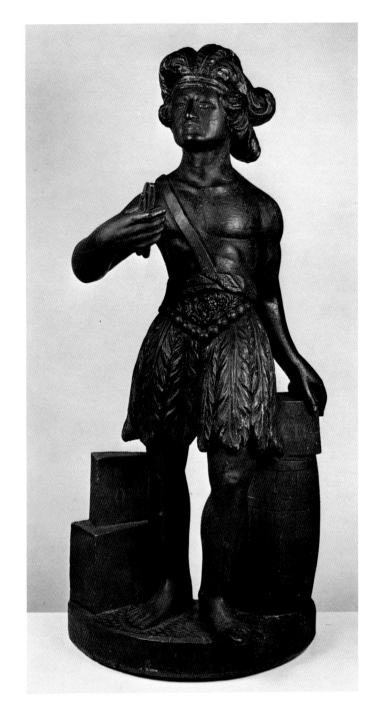

MAKER UNKNOWN

71. Civil War Soldier Whirligig

Polychromed wood, metal, and leather, 30½ in. high

Executed about 1870

Although some of the themes of whirligigs were quite elaborate, the solitary, standing soldier appears to have been one of the most popular. On this *Civil War Soldier*, the visor, hat, and buttons on the jacket, are made of metal, with traces of polychrome, which probably aided in its preservation. It also retains its original leather belt. Paddles, however, were frequently broken or lost, and the paddles on the arms of this one, made of metal, appear to be replacements.

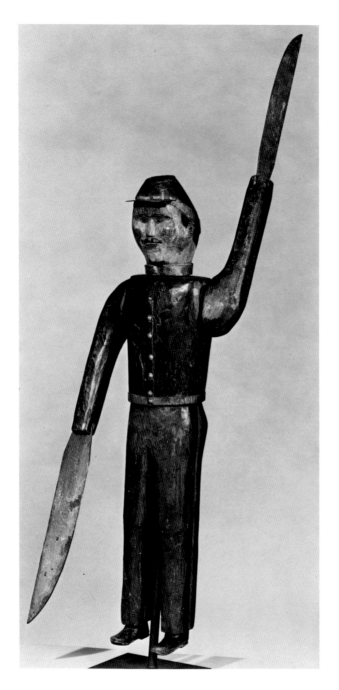

MAKER UNKNOWN

72. Emancipation Sculpture

Painted wood, carved and joined, 47 in. high
x 22 in. wide x 13 in. deep

Executed about 1880

It is thought that this work was carved by a
black man from the Midwest; it was made
after the Civil War to celebrate the Eman-
cipation Proclamation and the end of the con-
flict. The figure at the center represents
Abraham Lincoln; flanking him are two freed
slaves. Decorated with fraternal symbols,
the work is surmounted by a black dove of
peace.

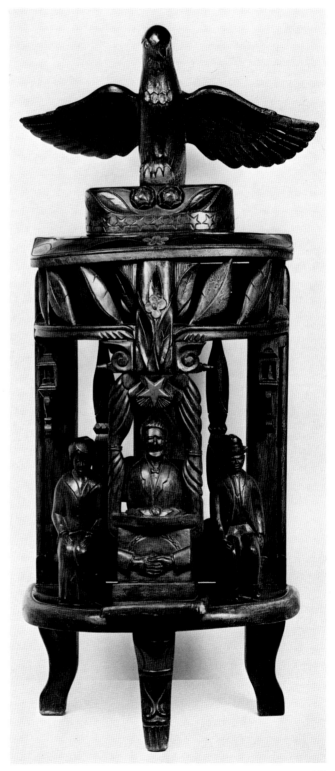

THOMAS V. BROOKS (1828-1895)

73. Indian Tobacconist Figure

Carved and painted wood, 79 in. high x 39 in. wide by 28 in. deep

Executed about 1880

Born in New York, Thomas V. Brooks became one of the most successful wood carvers of the nineteenth century, working first in New York City and later moving his workshop to Chicago, Illinois. He was known to have the largest stock of all the carvers on the New York docks.

This *Indian Tobacconist Figure* is one of the few surviving works by Brooks. Its large size and brightly colored paint create a powerful presence, making it a highly successful advertisement for the tobacco industry. Its purpose is made clear by the cigar box in the extended left hand and a cluster of tobacco leaves in the right. A nearly identical figure is illustrated in Frederick Fried, *Artists in Wood* (1970), p. 186 fig. 159. Closely related works are in the collections of the Maryland Historical Society, Baltimore, and the Shelburne Museum, Vermont.

ATTRIBUTED TO L.W. CUSHING &
SONS, WALTHAM, MASSACHUSETTS
(active 1867-1933)

74. Full-Bodied Goat Weathervane

Molded copper, with original gold leaf, 26 in.
high x 30 in. wide x 3¼ in. deep.

Executed about 1885

This is a rare, possible unique, form with an
extraordinary surface of blue-green verdigris
radiating through the original gold leaf. It is
attributed to the firm of L.W. Cushing &
Sons because the wood carving from which
the template, or mold, was made is almost
certainly the work of Henry Leach, who
worked for Cushing. Leach is acknowledged
to be among the finest carvers of his time.

ATTRIBUTED TO L.W. CUSHING &
SONS, WALTHAM, MASSACHUSETTS
(active 1867-1933)

75. Elk Weathervane

Molded copper and gold leaf, 35½ in. high x
31 in. wide x 5 in. deep

Executed about 1890

In 1867 L.W. Cushing and his partner Still-
man White bought A.L. Jewell & Co., Wal-
tham, Massachusetts. Included in the
purchase were Jewell's designs, some of

which were kept, others of which were elimi-
nated. Cushing later took over the business
completely and brought in two of his sons.

This *Elk* appears to be a unique form and
was, most likely, not a production piece but
rather was made at the request of a customer.

MAKER UNKNOWN, PROBABLY
PENNSYLVANIA

76. Multi-Level Whimsey

Carved and joined walnut, stained, 30 in.
high x 11 in. wide x 4½ in. deep

Executed about 1875-1900

Whimseys, also known as "all-of-a-piece-carvings," were carved from a single piece of wood. Usually fairly simply in composition, they were most often executed in soft pine by whittlers with pocket knives in their spare time.

This extraordinarily elaborate, multi-level whimsey was made to serve as a watch hutch. Carved in walnut, a relatively hard wood, it required special skill in its execution due to its complex carvings and varied facets. Each of the chains is made from a single piece of wood, as are the intricate cut-out posts between each of the levels. Animal figures and their young—a duck and ducklings on one level, a cat and kittens on another, and a dog and puppy on a third—adorn the piece, which is patriotically crowned by a carved eagle. The remaining level was reserved for the purpose of storing and displaying a pocket watch.

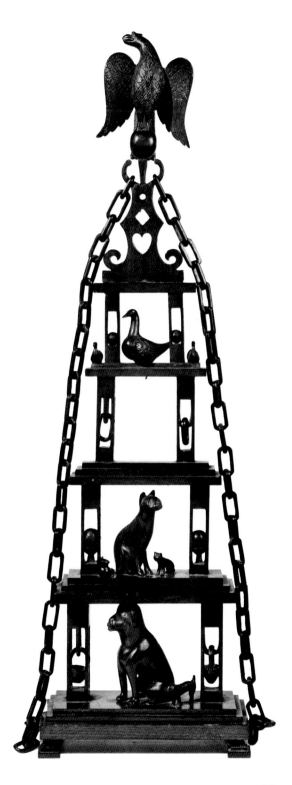

INDEX

All photographs by Helga Photo Studios, Upper Montclair, N.J.,
except nos. 36, 48, 49, 63, and 64

Typography by Compo-Set, Inc., N.Y.

Printed by Colorcraft Lithographers, Inc., N.Y.